IMAGES
of America

CAUMSETT
THE MARSHALL FIELD III
GOLD COAST ESTATE

IMAGES
of America

CAUMSETT
THE MARSHALL FIELD III
GOLD COAST ESTATE

The Caumsett Foundation
Foreword by Marshall Field V

ARCADIA
PUBLISHING

Published by Arcadia Publishing
Charleston, South Carolina

Printed in the United States of America

Library of Congress Control Number: 2015940906

For all general information, please contact Arcadia Publishing:
Telephone 843-853-2070
Fax 843-853-0044
E-mail sales@arcadiapublishing.com
For customer service and orders:
Toll-Free 1-888-313-2665

Visit us on the Internet at www.arcadiapublishing.com

*The Caumsett Foundation is proud to dedicate this book to Mr.
Alfred "Alfie" Kuntz for sharing his childhood memories and years of
employment at Caumsett, and to Dorothea L. Cappadona for her efforts
in leading the accumulation, preservation, and cataloging of Caumsett's
material history. The Caumsett Foundation acknowledges that this book
would not have been possible without their most generous contributions.*

CONTENTS

FOREWORD

Like my great-great-grandfather Marshall Field, I was born and raised in Chicago. I was eight years old when I first visited my grandfather's (Marshall Field III) grand estate on Long Island. As the driver drove up to what he thought was the Main House, he realized that he had mistakenly pulled curbside to what was actually the Polo Barn. The Polo Barn is a wonder in its own right of course, at the time elegantly housing 14 of grandfather's polo ponies. Eventually, we made it up the meandering parklike drive to the house where grandfather and his wife, Ruth, spent their autumns.

I recall my grandfather taking me to the roof of the Main House to view the many boats and seashore visitors. We sometimes watched them through a telescope. The rooftop was easily accessed by the second floor's stairway via a hatch-like door. When visiting the park back in 2002 during the foundation's annual benefit, I looked back fondly on those days. Along with me to share my memories were my wife, Jamee, our daughters, Jamee, Stephanie, and Abigail, my son Marshall, and his daughter Chloe. We got a chance to climb the same steps to the rooftop and view the glorious Long Island Sound with the same heart-shaped pond in the foreground.

The Main House that I remember was now smaller due to the 1950s removal of two wings. As I was told, many of the area's great houses were falling to the wrecker's ball, while others were being sold to developers. This was a quite common practice to the area's large estates due to their ever-increasing property taxes. Luckily, in 1961, Caumsett was purchased and placed in the trustworthy hands of the New York State Department of Parks, Recreation and Historic Preservation.

Today, in partnership with NYS Parks, we are lucky to have the Caumsett Foundation watching over this former Gold Coast estate and its glorious 1,500 acres of natural beauty. The foundation is a model friends group dedicated to its preservation, and for that I am thankful. Maintaining the buildings and grounds is quite a feat when you think that my grandfather had almost 100 staff members dedicated to its cause back in the day.

From the Dairy Barn Complex, out to the Main House, back to the Polo Barn, and then down Daffodil Hill, Caumsett is certainly the jewel of New York State Parks.

—Marshall Field V
April 2015

ACKNOWLEDGMENTS

The main subject of this book is the history of the Caumsett State Historic Park Preserve. In telling the story, we will briefly focus on the life of Marshall Field III and his numerous family members. We will continue with the history of the estate and the park it became. The Caumsett Foundation History Committee, led from 1997 to 2015 by Dorothy Cappadona, has, over the years, assembled, processed, and cataloged more than 4,000 items. We have gone through all of them and selected the most interesting to display in the pages that follow.

Unless otherwise noted, images are courtesy of the Caumsett Foundation archive. Most of these "interesting" selections were explained in additional detail by an amazing person, Alfred Kuntz. "Alfie" grew up on the estate, where his father, Albert E. Kuntz, spent more than 40 years as an employee of Marshall Field. Alfie followed in his footsteps. He is the last living former employee of Field's Caumsett estate.

We are pleased that most of the captions to the photographs in this book give not only a historical explanation of the subject, thanks to Dorothy and her committee, but also a personal one, thanks to Alfie's wonderful memory.

The Caumsett Foundation thanks Lloyd Harbor village historian Walter D. Kolos for providing material used in the introduction. We also thank the History Committee members for their hard work, and John F. Barone for selecting, enhancing, and assembling the material into this format.

INTRODUCTION

Caumsett's terrain is the result of a glacier's retreat thousands of years ago. The preserve is known for its vast woodlands, gently undulating fields, meadows, and steep valleys. Perhaps its most distinctive feature is the dramatic and varied shoreline, also a gift from glacial activity. The mountainous sand and clay cliffs, boulder-strewn beaches, forested harborside, and extensive tidal wetlands are treasures of the property.

The primeval nature of Lloyd Neck changed with the arrival of the Lloyd family in the early 18th century. The Manor of Queen's Village, under the guidance of Henry Lloyd and his family, would become a viable plantation under the English system. Woodland was cleared for pastures and farming. The remaining forest was harvested for its valuable oak, hickory, and chestnut. There was also an abundance of deer, turkey, quail, and other wild game. Specimen fruit trees were introduced, especially apple. The woods at Caumsett were further altered by heavy logging by occupying forces of the British army during the Revolutionary War. They were responsible for the destruction of much of Lloyd Neck's timber, most of it either sold or used for fuel. It is estimated that 75,000 cords of wood were removed from the neck during the occupation period.

By the time Marshall Field came to Long Island to establish a country home, most of the prime real estate on the western North Shore had already been claimed. Land providing woodlands and spectacular water frontage was becoming impossible to locate. Lloyd Neck, however, had it all, and Field instantly knew it. On June 12, 1921, he quickly and quietly purchased three large tracts of land there. The combined property was bounded by a wide, protected harbor to the south and by seemingly endless beaches on Long Island Sound to the north. Field had purchased land that had become an untended backwash of old or abandoned farms. The 1921 acquisition, titled in his wife's name, contained about 400 acres of cleared land and another 1,600 acres of abundant woodlands. With the landscape genius of the firm Olmsted Brothers and an army of subcontractors, Field set about shaping the property to his tastes. However, he left one of its most vital features, the north and south shorelines, basically untouched.

Caumsett was not to be a "seaside" retreat for the Fields, as they would spend their summers in Maine. It was to be their country retreat, a place for sporting activities and formal entertaining, just 32 miles (as the crow flies) from their New York City waterfront penthouse apartment. This distance could be quickly covered by automobile, boat, or seaplane. The 2,000-acre Lloyd Neck property was the perfect setting for Field's first loves: equestrian activities and hunting. By 1928, Marshall and Evelyn Field had successfully re-created a completely self-sufficient country estate, much like the one that Field had enjoyed during his childhood in England. Re-creating such an estate entailed the creation of hills, swale, gardens, ponds, meadows, forested areas, roads, and buildings. It involved the removal of cemeteries, the creation of a causeway, the construction of docks (to receive the building materials), the hiring of an architect, a landscape architect, and hundreds of construction workers, the dredging of an existing pond, and the creation of a water source and a power supply. In addition, 32 structures, ranging from a three-stall bull-breeding pen to a 65-room, fire-resistant Main House, would be built. Following the standard commercial guidelines of the day, Field spent more than $6 million to ensure a professional build at Caumsett. For his money, he received a high-quality, authenticated turnkey, fully operational country estate—one that appeared like it had been there for decades.

The Caumsett Foundation is pleased to present this book as a summary of that building transformation, the "Gold Coast living" that would follow, and ultimately, the long and arduous process by which the estate would become one of the most cherished and admired properties in the New York State Parks system. The history of Caumsett is fascinating not only because of its unparalleled grandeur and productivity, but because of its very short life span. However, Marshall Field's Caumsett has left an indelible imprint through its rebirth as a National Register of Historic Places site and a New York State historic park preserve. Its remarkable story, however, is known to few and has gone uncelebrated in histories and records—until now.

One

THE FIELD FAMILY AND EVENTS

Marshall Field III had the distinction of being one of the richest men in the world during most of his lifetime. He had, at age 13, inherited a trust fund worth more than $160 million from his grandfather Marshall Field I, who had founded the legendary department store. Marshall III once said in a speech: "I happen to have been left a great deal of money. I don't know what is going to happen to it and I don't give a damn. If I can't make myself worthy of three square meals a day, then I don't deserve them."

Marshall Field III, born on September 23, 1893, was one of three children. His father and grandfather died just months apart in 1906. His mother, Albertine, took the family to live in England. Marshall III was educated at Eton and at Trinity College, Cambridge. At 21, in accordance with the instructions in his grandfather's will, he returned to the United States to take over trusteeship of the Field estate.

He would return to Europe three years later to join the world war. Field served in the US Army as a field artillery private. He left the service as a cavalry captain and was awarded the Silver Star for gallant action in France. After the war, he went on to become a very successful financial salesman, eventually starting his own bond-trading firm.

Marshall and his first wife, Evelyn, had three children—Marshall Field IV, Barbara, and Bettine. The couple divorced in 1930. A second wife, Audrey James Coates, arrived a few months later and left in 1933. Ruth Pruyn Phipps joined Marshall as wife number three in 1936. She brought with her two sons, Harry and Bobby, and the couple had two more children, Phyllis and Fiona, soon thereafter.

Field had a keen eye for business and used his fortune wisely as the head of Field Enterprises. At one time, he served on the boards of directors of 12 companies. But his life was not all about money. In the mid-1930s, Field came down with a severe case of depression. He sought professional help and soon placed many of his business ventures in a trust. He then turned to philanthropy and social services, particularly in the fields of child welfare and race relations. The Field Foundation was incorporated mainly to support these purposes.

Marshall Field III was at his beloved Caumsett in late October 1956, when he took ill. He passed away on November 8 after an operation to remove a blood clot in his brain. He was 63.

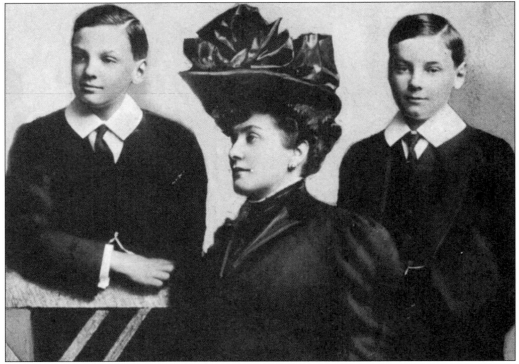

Shown here are Marshall Field III (left), Albertine (Mrs. Marshall II) Field (center), and Marshall's brother Henry Field (right). The photograph was taken on the Field estate in Cadlands, in England, where Field developed his love of formal English country estates. His grandfather had decided that the bulk of his fortune would be left in trust to the firstborn grandson. Henry received much less, and female family members got almost nothing. The elder Marshall Field was terrified that the husbands of the female children would somehow gain control of any inherited money. (Courtesy the *Chicago Sun-Times*.)

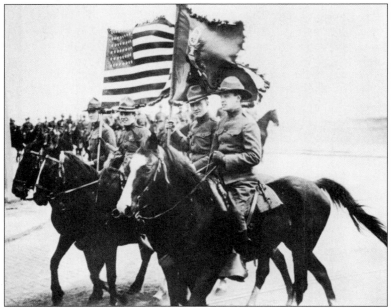

Marshall Field III (right) joined the US Army in World War I as a field artillery private and left as a captain, receiving the Silver Star for gallant action in France. (Courtesy the *Chicago Sun-Times*.)

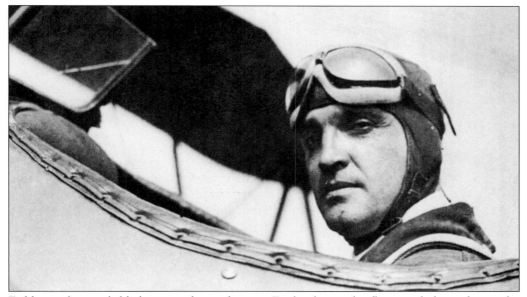

Field grew from a child playing with toy planes in England to a pilot flying real planes during the war. Although assigned to the Army's cavalry division, Field was instrumental in doing research for, and even partially funding, the newly formed Army Air Forces unit. He participated in the development and testing of newly designed aircraft, and returned home and immediately purchased a plane. For a short while, Field enjoyed the use of neighbor William J. Matheson's Fort Hill landing strip, located next to the formal gardens. (Courtesy the *Chicago Sun-Times*.)

Field married New York debutante Evelyn Marshall in 1915. Marshall and Evelyn had three children—Marshall Field IV, Bettine, and Barbara. Evelyn was said to have been a difficult person. She preferred not to have any contact with nonessential help, going so far as to successfully have tall plantings installed at Caumsett to shield employee walkways and changing the location of employee housing to the southwest side of the property. The couple divorced in 1930, but Field was generous to her. She received a $1 million annual income for life, a New York City apartment, and custody of their three children.

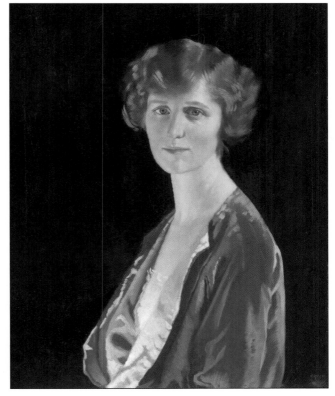

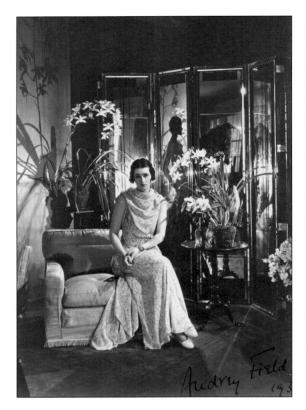

Audrey James Coates became Marshall Field's second wife in 1930, just two weeks after his divorce from Evelyn was finalized. She was the English-born widow of Capt. Dudley Coates and goddaughter of King Edward VII. Audrey, a well-known socialite in both England and the United States, was a member of a very wealthy English family. Here, she is pictured in a room in the Main House filled with flowers grown by the staff of the estate. Upon their divorce three years later, Audrey simply left, with no payment of any kind from Field. She returned to England and "civilization," as she bluntly put it. Field's lawyers, however, took no chances, and a major change in estate ownership took place. In 1934, Caumsett was split into two corporations. Caumsett Estates became the owner of the residential and recreation portion of the estate, and Caumsett Farms took over ownership of the farm group operations. The lawyers insisted on the corporate restructuring in case Audrey changed her mind.

Audrey Field liked to entertain, and entertain she did—usually on the grandest scale. Preparations are shown here for her biggest event, the 1932 Dutch Treat Circus charity fundraiser. Friend Lucinda Goldsborough Ballard is shown creating props of sideshow caricatures for the event's photographic booths. Family friend George Gershwin (right) contributed advice and a final touch of paint for Ballard's work.

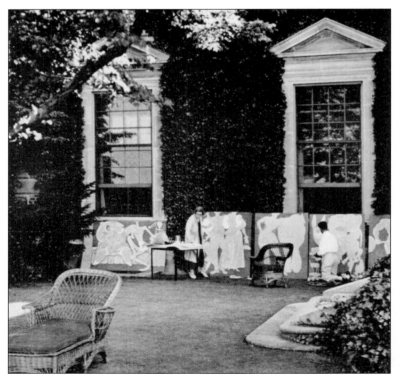

The invitation describes the "Circus Party" as a "not fancy dress" affair, although the guests arrived in black tie and floor-length gowns. As indicated here, guests were expected to have a sense of humor and a certain amount of talent. The best in society and the entertainment world were there, including George Gershwin, Fred Astaire, Helen (Mrs. Payne) Whitney, William K. Vanderbilt, Millicent (Mrs. William Randolph) Hearst, and the Vincent Astors. Funds raised that night benefited the Cold Spring Harbor Laboratory.

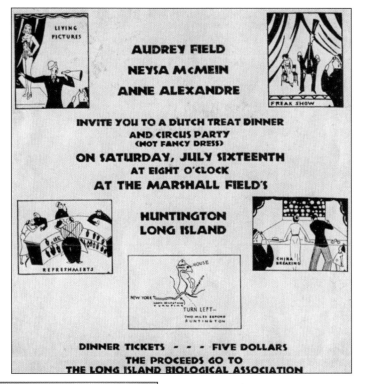

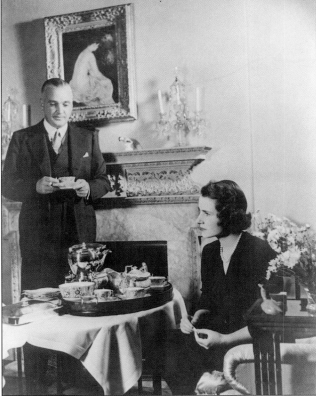

Field's third wife was the former Ruth Pruyn Phipps. It is said that his first wife, Evelyn, made the initial introduction, as both were living (separately) at the River House in New York City. The couple was married in 1936. She brought two sons along with her, and the couple had two more children, Phyllis and Fiona. Ruth would remain married to Field until his death 20 years later. The third time was truly the charm for Field, as he and Ruth enjoyed a wonderful marriage together.

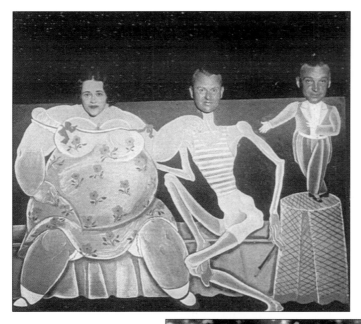

Shown here are Audrey Field (left), Wadsworth R. Lewis (center), and Marshall Field III. Suffice to say, no one had ever seen anything like the "Circus Party." Guest were asked to pay for their dinner, drinks, and after-dinner activities. An astounding percentage of guests were still on hand at 5:00 in the morning. The event was highlighted in most New York newspapers in a positive fashion: "one of the funniest parties of the season," "a new pattern in parties," and a "unique charity entertainment."

Marshall Field III and his third wife, Ruth, are seen here. The Fields attended horse races with their close friends the August Belmonts. Often, Field had entries in Belmont races, and many trophies were taken home to Caumsett. As the 1930s progressed, the social life at Caumsett became less ostentatious. In a country reeling from an economic depression, life was relatively secure for those working on the estate. No one was let go, and most employees had free housing, along with daily meat, dairy, and vegetable rations. Field also took care of all utility expenses of on-site employee housing.

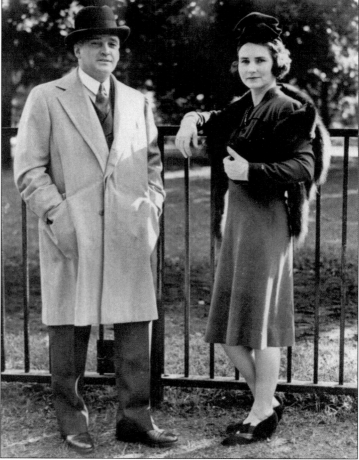

Marshall Field III is shown at his desk at the new *Chicago Sun* newspaper. The first issue hit the streets on December 4, 1941, just days before one of the biggest events in US history. Field also had an office on Wall Street, where his brokerage firm was a major bond trader. This is where he earned most of his personal fortune. He was an intelligent and successful businessman. (Courtesy the *Chicago Sun-Times*.)

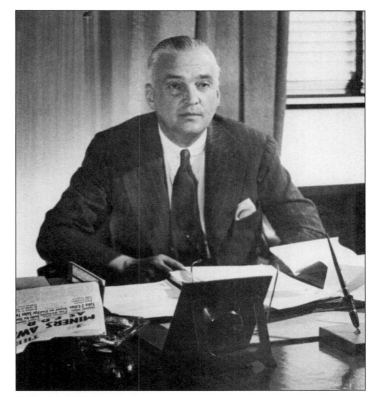

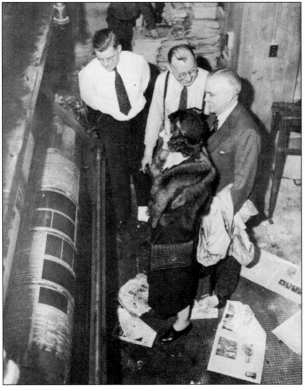

Marshall and Ruth (right) watch a test print run of the new *Chicago Sun*. Field was extensively involved in all aspects of the newspaper, even sitting in on editorial meetings. The newspaper became an outlet for his liberal political beliefs, which soon earned the scorn of other socialites, who referred to him as a "traitor to his class." (Courtesy the *Chicago Sun-Times*.)

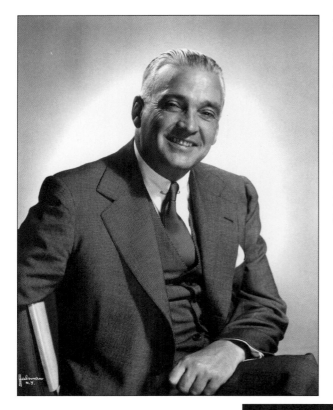

Field poses here at approximately 50 years of age. He was in good health, spending hunting season and Christmas at Caumsett. He loved to dress up as Santa Claus, inviting all of the children living on the estate to join him in the formal living room to receive a gift. Field assigned his personal secretary, Gesine Heller, to contact every family on the estate to find out what each and every child wanted for Christmas. Field, who loved children, took great joy in this annual event.

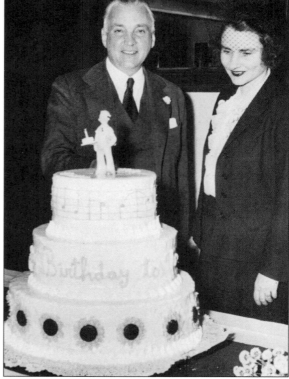

Marshall and Ruth celebrate the first anniversary of the *Chicago Sun*. The first year was a successful one for Field's publishing career. The newspaper had a Democratic slant, but did not favor any one political party. The paper was known for a high quality of journalistic content, and did not sensationalize front-page stories in the name of circulation gains. (Courtesy the *Chicago Sun-Times*.)

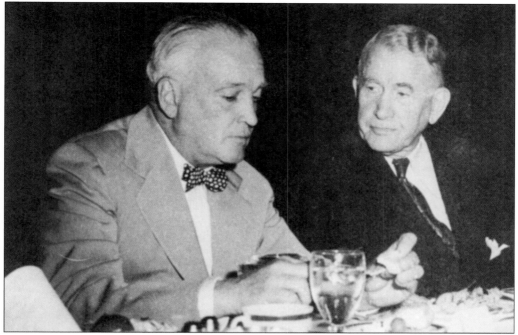

Marshall Field III (left) is shown here with Vice Pres. Alben Barkley. Field was a staunch supporter of Pres. Franklin Delano Roosevelt and the New Deal programs proposed by his administration. He felt strongly that the people suffering during the Depression deserved and were entitled to help from the government. Field never shared the opposing view, that this class of citizens were acting as freeloaders.

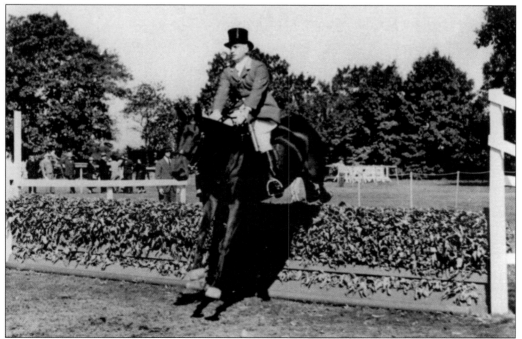

Marshall Field III jumps a hedgerow at Caumsett around 1940. He loved the outdoors and was a very accomplished rider, probably due to his English upbringing.

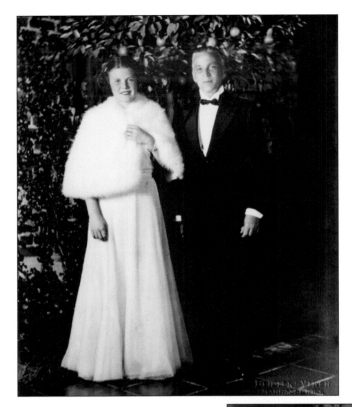

Barbara and Marshall Field are seen here in June 1936. She was the eldest daughter of Field's first wife, Evelyn. This photograph was taken at her coming-out party, held in the boxwood garden to the west of the Main House. This was the most extravagant family affair ever held at Caumsett. The Main House was supplemented with a huge tent with a pink satin ceiling, and thousands of Noguchi Japanese lanterns were strung all the way down to the water from the balustrade.

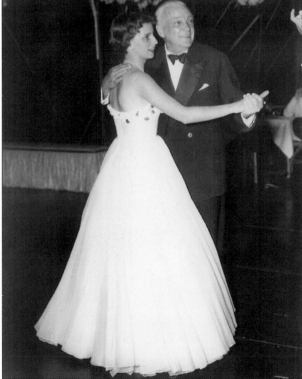

Phyllis and Marshall Field dance at her coming-out party in June 1955. Held at the Main House, it was also an extravagant event. Mr. and Mrs. Field were at perhaps the top of their social game at this point, and the attendees were a who's who of the New York and Chicago social scenes. Parents usually invited the children of their friends to these parties, who often did not know each other or the guest of honor. This was a convenient way of encouraging "suitable" dating and possible marriage arrangements.

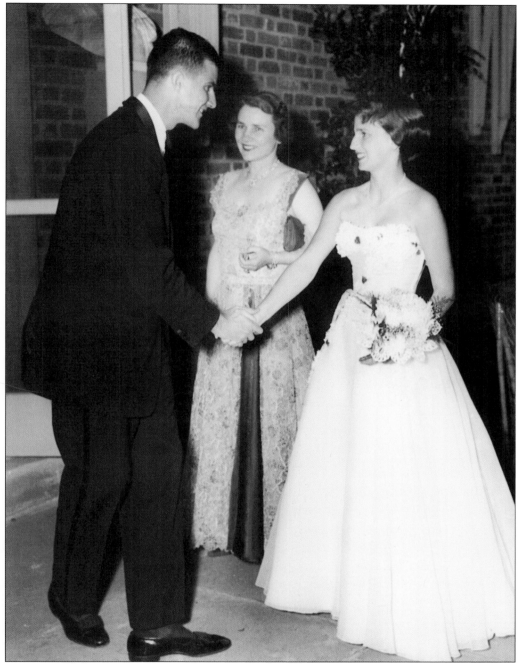

A guest makes contact with Ruth (center) and Phyllis Field. Barbara Bliss, first grandchild of Marshall Field III, remembers the night well, "When I was 15, I was invited to Phyllis's coming out party. It was not held in a tent outdoors as my mother's had been, but inside the Main House grand entrance hall. I remember the sounds of the orchestra that played all night long. I felt very special being the only grandchild included on the night Phyllis became a sophisticated lady. I had never seen her so grown-up. She had an easygoing manner and wasn't competitive with me like her sister Fiona. That night, however, I said a sad good-bye to a piece of my childhood."

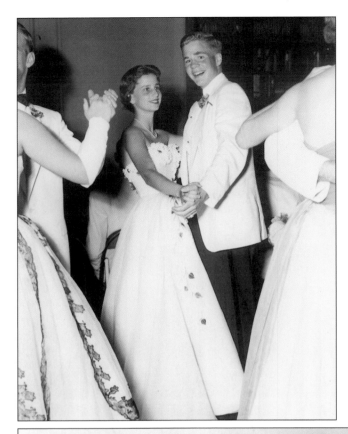

Phyllis and her stepbrother Bobby Phipps share a dance. Phipps was quite a character. During a long absence by Ruth and Marshall, Phipps decided to "reconfigure" their 1939 Ford Town Car, a semiretired chauffeur-driven formal vehicle used by Marshall. Phipps thought it would better serve as a hot rod, and he succeeded in the conversion. He crashed it one day during a test run, driving on the Main Road toward the Main House. He failed to negotiate the curve after the dip in the road near the house and hit a tree.

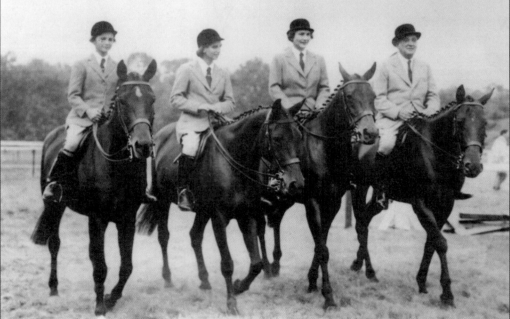

Members of the Field family pose on horses at Caumsett. They are, from left to right, Fiona, Phyllis, Ruth, and Marshall III. Fiona and Phyllis were known as exceptional riders.

Phyllis Field stands at her coming-out party. Her flowers were grown and personally arranged by head gardener George Gillies.

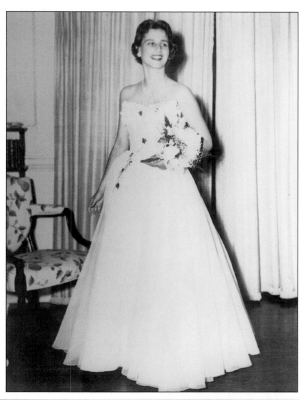

In late June 1955, Phyllis became engaged to Hernando Samper. He worked for the secretary-general of the United Nations. They were married later that summer. The wedding party is shown here in the loggia room of the Main House. The marriage took place at St. John's Church in Cold Spring Harbor. The reception was held at the Piping Rock Club, where the Fields held a membership.

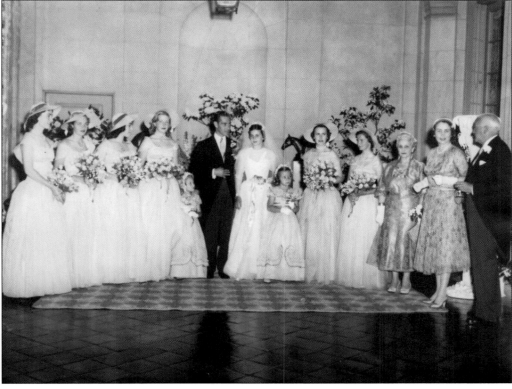

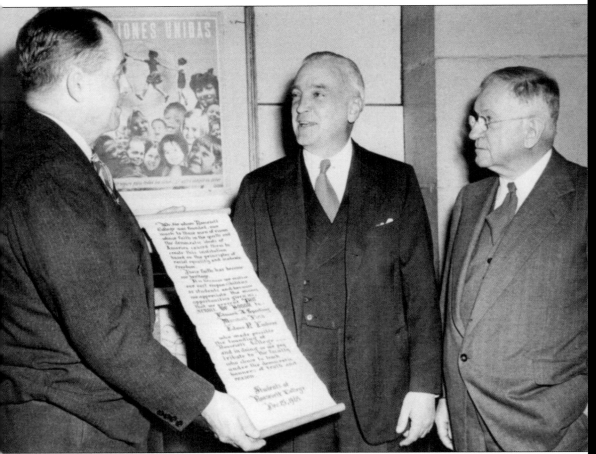

In December 1948, Field (center) receives an honorary degree from a college he helped to prosper. Thomas Jefferson College was founded in 1945 with a mission Field firmly agreed with: "To make higher education available to all students who qualify academically, regardless of their socio-economic status, racial or ethnic origin, age or gender." Field, although one of the richest persons on earth, was a true champion of those less fortunate, no matter their physical appearance. He was attracted to the school and its purpose by an old friend. The school began as Thomas Jefferson College when YMCA College president Edward J. Sparling (right) refused to provide his board of directors with student demographic data. Sparling was afraid that the board would install a quota system to limit the number of minorities and women at the school. Sparling resigned his position, taking a number of faculty and students with him. He started the new college with extremely limited funds. Just two weeks later came news of the death of Pres. Franklin D. Roosevelt. Sparling reached out to Roosevelt's widow, Eleanor, and obtained permission to rename the school Roosevelt College as a tribute. Mrs. Roosevelt contacted her friend Marshall Field III to gauge his interest as a sponsor of the school. He immediately accepted the challenge.

Two

PLANNING AN ENGLISH ESTATE

The design and construction of Caumsett was a phenomenal operation, especially for the early 20th century. When Marshall Field purchased the property, it was a tract of overgrown woodlands and abandoned farms. With the landscape genius of Olmsted Brothers and the architectural talent of John Russell Pope, this rural backwater would be transformed into a residential showplace.

Woods were cleared, roads were built, and a central water system with fire hydrants was installed. Electrical and telephone lines were placed underground, and a modern sewage system was installed at each structure. Starting in 1922, an ambitious building program commenced. The Main House, Polo Barn, Winter Cottage, and the Farm Group were constructed at breakneck speed. Only the finest and most-modern construction materials were used. The greenhouses, indoor tennis court, and a myriad of smaller houses and dormitories for resident employees were completed on the estate by the spring of 1927.

The landscaping was done with equal speed, as full-sized trees were barged in and planted. Mature shrubs were planted and hillsides of mountain laurel were transplanted. Photographs taken in 1927, when the Fields took occupancy, show the building and grounds looking firmly established. In the years to come, Marshall Field would continue to purchase property from neighbors, sometimes after intense negotiations. For example, the underwater access rights to estate-owned Fly Island were purchased by Field after an intense bidding war with neighbor Sherman Fairchild.

Construction of the Farm Group, also designed by John Russell Pope, had a design that was consonant with the Georgian Revival tradition of the other estate structures. The attention to detail was remarkable. Field employed Alfred Hopkins, a noted scientific expert on modern farm buildings at the time, to assist Pope with the design of the Farm Group building interiors and placement of the necessary equipment. Buildings, no matter how utilitarian, had architectural features that were carefully considered. Dentil moldings, fan windows with delicate tracery, and numerous other classical details were employed to create an aesthetic composition.

Although the complex uses different styles and configurations, it is visually unified. A rhythmic series of horizontal lines is punctuated by two silos, a classical cupola, and numerous roof vents. Even though the Farm Group does not possess the regal grandeur and symmetry of many of the other large buildings at Caumsett, it is still a pleasing—and very imposing—collection of shapes and sizes.

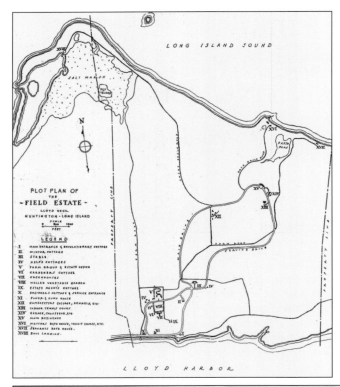

This is the original "Plot Plan" for Evelyn Field's estate. For legal reasons, the entire estate was purchased, built, and operated under the sole legal ownership of Evelyn Field. The starting budget, including land purchase, was $3.5 million. The final tally at the end of construction, in 1927, was almost double that amount. Operating expenses each year would be approximately five percent of the final cost.

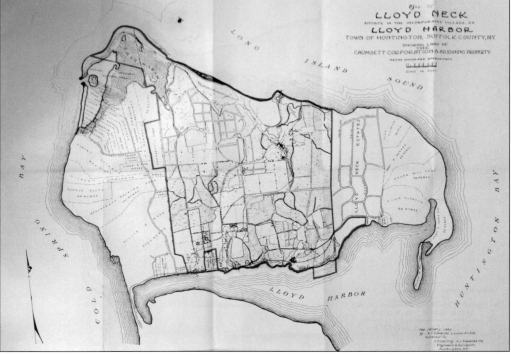

This 1943 estate map by engineering firm A.J. Edwards shows the completed property and the surrounding area. Note that the current Fiddlers Green Association property (center right) of 374 acres was originally part of the Caumsett estate.

This is a chart of the estate construction's project management. Construction at Caumsett was designed to be as efficient and cost-effective as possible. Project manager Adolph Frank was technically responsible for every nut and bolt put into place. He had been educated in, and had immense experience with, design, engineering, and construction. He also had extensive managerial capabilities. Every design and all material samples crossed his desk for approval. Under great pressure from Evelyn Field to both perform and keep within stated budget and time guidelines, Frank worked long hours, seven days a week, often sleeping at his desk. (Courtesy Architectural & Building Press Inc.)

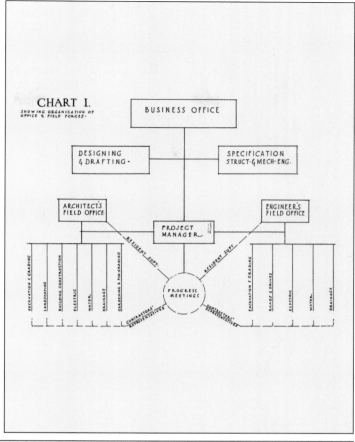

CHART I.
SHOWING ORGANIZATION OF OFFICE & FIELD FORCES.

BUSINESS OFFICE

DESIGNING & DRAFTING.

SPECIFICATION STRUCT. & MECH. ENG.

ARCHITECT'S FIELD OFFICE

ENGINEER'S FIELD OFFICE

PROJECT MANAGER

RESIDENT SUPT.

RESIDENT SUPT.

PROGRESS MEETINGS

EXCAVATION & GRADING
LANDSCAPING
BUILDING CONSTRUCTION
ELECTRIC
WATER
DRAINAGE
GARDENING & FIN. GRADING
CONTRACTORS' REPRESENTATIVES

EXCAVATION & GRADING
ROADS & DRIVES
ELECTRIC
WATER
DRAINAGE
CONTRACTORS' REPRESENTATIVES

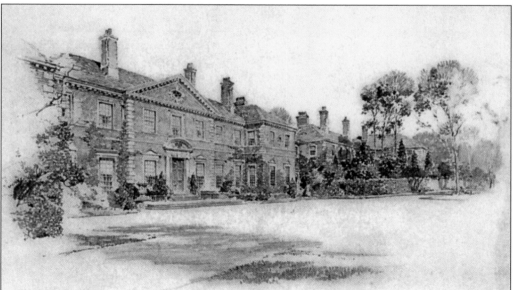

The drawings on the next three pages are the final designs shown to and approved by Marshall and Evelyn Field. Depicted here is the front of the Main House. (Courtesy Architectural & Building Press Inc.)

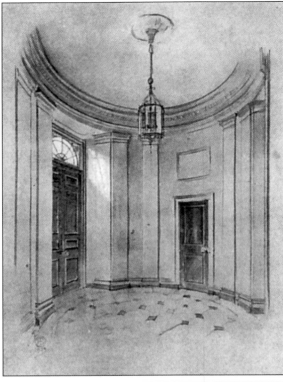

This is a preliminary drawing of the Main House vestibule. With regard to any area where the family would have personal contact, design sketches were drawn for Evelyn Field's approval. She gave each sketch a considerable amount of study, often returning approved paperwork with numerous changes and additional requests. (Courtesy Architectural & Building Press Inc.)

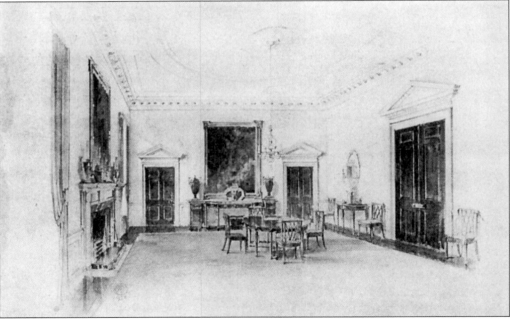

This is a sketch of the dining room of the Main House. Caumsett was designed to be a country estate with the goals of entertainment and relaxation for its owner and guests. While most living areas were designed for comfort, some, including this dining room, were designed with a formal use in mind. The Fields would entertain a who's who of invited guests in this room. (Courtesy Architectural & Building Press Inc.)

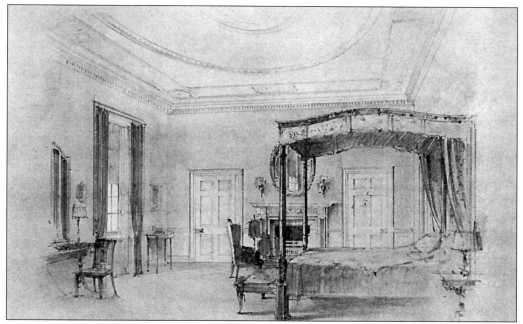

This drawing shows one of the proposed Main House bedrooms. Field and his wife, Evelyn, had large but separate bedrooms. Evelyn was on the west side facing Long Island Sound, and Marshall was on the east side, also facing the sound. Their rooms were connected by a large living area where they would spend their evenings before retiring. (Courtesy Architectural & Building Press Inc.)

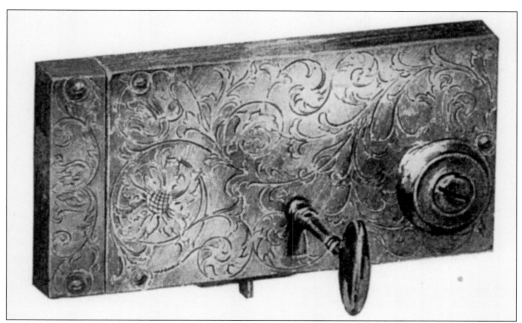

This is a drawing of a proposed door lock for Main House. The Caumsett estate had hundreds of door locks, but, through a simple system of keyed-alike master keys, the operational complexity was kept to a minimum for both family and staff.

Daffodil Hill, near the Main Drive, is shown here, before the daffodils were planted. In a planning meeting, Marshall Field told head gardener George Gillies to buy a lot of daffodils, as Evelyn was very fond of them. Gillies asked how much he should spend. Field's wife, Evelyn, replied that he could spend the same amount on the purchase and installation of the daffodils as the cost of one of Marshall's prized polo ponies. As a result, seven months later, the Long Island Rail Road finished transporting the 27th freight car of bulbs imported from Holland. Today, daffodils are located all over the park's acreage. Gillies planted them everywhere he thought Evelyn might visit.

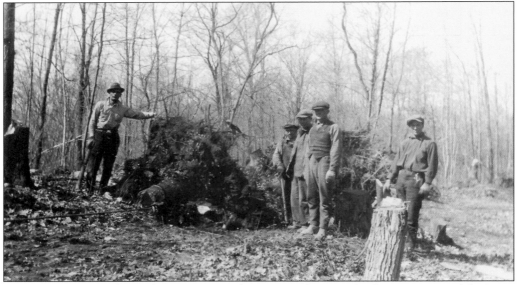

Note the lack of mechanical equipment in this c. 1922 photograph of construction of the Main Drive. The rope attached to the tree stump is probably secured to a team of horses. Getting men and any available machinery to the construction site was very difficult, as the causeway between Lloyd Neck and Lloyd Harbor was not fully functional. During construction, Marshall Field got together with neighbor William Matheson and shared the cost of building the current Causeway. Lloyd Harbor Road, a dirt path at the time, was widened, regraded, and, like the Causeway, finished with a concrete base. To speed up construction, Field authorized the dredging of Lloyd Harbor and the building of two docks, one at the bottom of Lloyd Lane and one at the Service Drive entrance. These docks would act as shipping and receiving locations. Construction materials were brought in, and trees cut down during the construction process were shipped out.

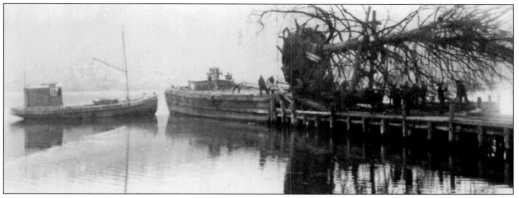

Evelyn and Marshall Field wanted to move into an English-style estate that looked as though it had been there for decades. But how would this be possible, since the landscaping was mostly new? Olmsted Brothers and Hicks Nursery, of Westbury, New York, came to the rescue. Hicks found several 100-year-old trees near Brightwaters on Long Island. The trees, in excellent condition and each over 70 feet in height, were uprooted, and the branches and roots were protected. The trees were then loaded onto a special 90-foot barge. With the aid of a tugboat, they took a ride through the shipping lanes of New York City, making their way to Long Island Sound and then, finally, to the beach near the Main House. Under the direction of head gardener George Gillies, they were planted near the Main House and thrived for decades. The Fields got their desired "look."

This is the marsh area near Fly Island in the early 1920s. This photograph is thought to be one of the oldest in the Caumsett Foundation collection. This was not part of the original estate land acquisition, Marshall Field would negotiate the purchase of the area in the 1930s.

This c. 1930 photograph offers a look at the dairy field. Almost immediately, Field initiated dairy and farming operations at Caumsett. This was probably due to the fact that he sincerely wanted to replicate a working English estate. No expense was spared. The buildings in the Dairy Barn Complex were of high quality and had the most-modern tools and equipment. The livestock was procured from all over the United States and was exceptional in quality. In most cases, Field and his management team simply sought out and purchased cattle that had won an award for being best in class—no matter where that event had taken place. The inclusion of the dairy farm component at Caumsett was also a huge benefit during World War II. While other estates were severely limited in their operating functions due to hard-to-find material and government rationing, Caumsett received an exemption to most rules and regulations due to the fact that it was classified, and thus registered, as a farm operation. It must also be noted that the dairy and farming operations probably gave Field various forms of tax savings. This would have certainly been true when property tax classification rules came into existence.

Three

READY FOR OCCUPANCY

Caumsett basically had unlimited funding, and the results speak for themselves. This chapter features photographs taken near the completion of, or after, construction. They attempt to show the high level of work performance and build quality that Marshall Field received for his money. He hired only the best people and purchased only the highest-quality materials.

This was a difficult result to achieve however. Architect John Russell Pope struggled with the concept that he had unlimited funds at his disposal but his clients did not want to appear ostentatious. Here is one example: Around this time, greenhouse designs were extravagant. Fancy, custom-shaped windows of all designs were in vogue. Center atriums of extreme height focused on form instead of function. Field decided that the greenhouse complex at Caumsett would be commercial in form and function. He thus had built a highly efficient and most industrial-looking design. The multi-award-wining output produced however, would go on to validate his wishes.

Here is a quote from architect Pope on this subject:

> The advantage of wealth has been accepted as an opportunity to employ the best materials, rather than to purchase superfluous ornament and pretentious decorations to suggest riches. One might suppose that, with seemingly unlimited means, the problem of designing the interior was reduced to a minimum. The fact is, however, that one of the great difficulties under such circumstances is to avoid elaboration and to intensify on the interpretation of character.

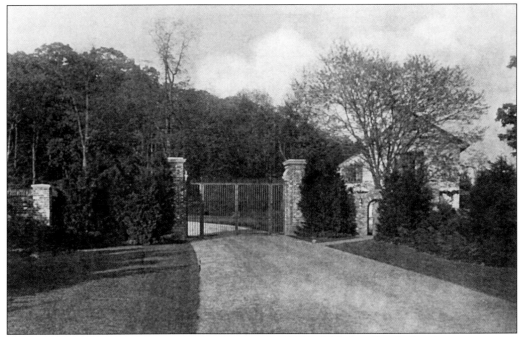

This is the main estate entrance gate. Driving along Lloyd Harbor Road, the first entrance to Caumsett was the Service Drive. The main estate road was the second entrance a visitor reached, just before the Henry Lloyd Manor House. (Courtesy Architectural & Building Press Inc.)

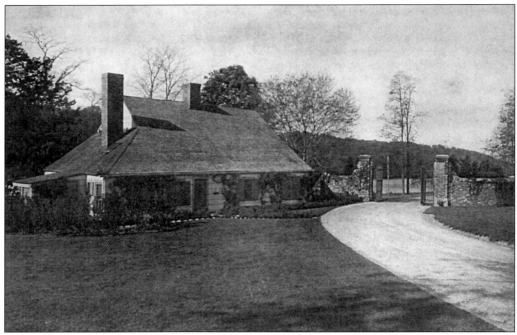

Shown here is the estate gatehouse, also known as the Henry Lloyd Manor House. (Courtesy Architectural & Building Press Inc.)

Pictured here is the rear of the Main House. The design featured a large stone patio and hardware attached to the walls to make the installation of awnings and tents easier. Such was the extensive thought process at the estate during the design phase. The view of Long Island Sound from the patio was nothing short of spectacular. This area was a popular staging point for many of the Field party events. (Courtesy Architectural & Building Press Inc.)

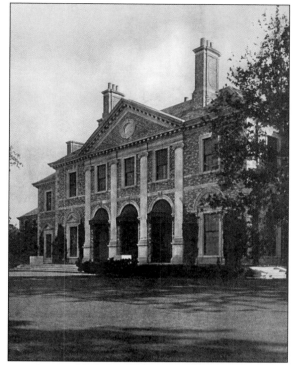

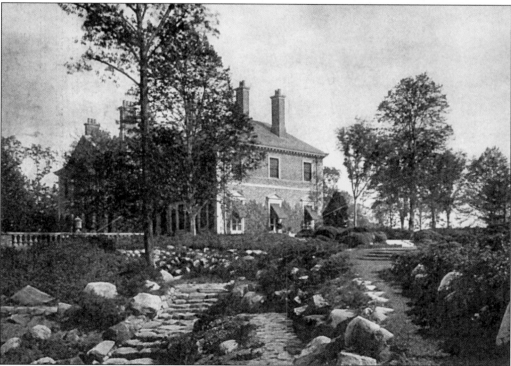

This is a northwest view of the Main House, showing its original rock garden, designed by Evelyn Field. Note the full west wing, which was removed in the late 1940s. (Courtesy Architectural & Building Press Inc.)

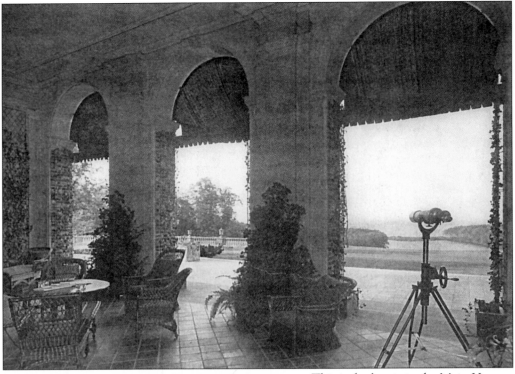

This is the loggia in the Main House. In warmer months, the heavy wood doors were removed to form an enclosed patio setting. This was a family favorite place to be during warm-weather periods for light dining and entertaining. As seen here, the view included not only the fresh pond but also a wide view of Long Island Sound. (Courtesy Architectural & Building Press Inc.)

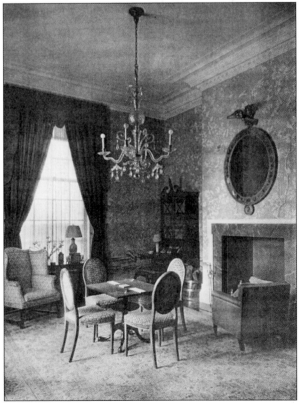

The Main House cardroom is pictured here.. The Field family very much enjoyed playing card and board games with their guests. Note the furniture. The finest craftsmen of old England and early America were represented throughout the house. Many of the pieces purchased for daily use would have been worthy of museum display. (Courtesy Architectural & Building Press Inc.)

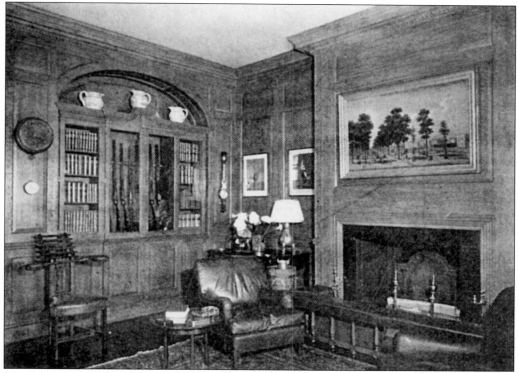

This is the Main House gun
room. Marshall Field was an
avid gun collector. Most of the
woodwork in this room (and the
dining room) was antique. The
wood was taken from stockpiles
Evelyn Field had collected from
older homes in both the United
States and Europe. For example,
an entire wall was taken from
an old house in Newport, Rhode
Island, and installed in a guest
room. Such attention to detail
became a trademark of Mrs.
Field. (Courtesy Architectural
& Building Press Inc.)

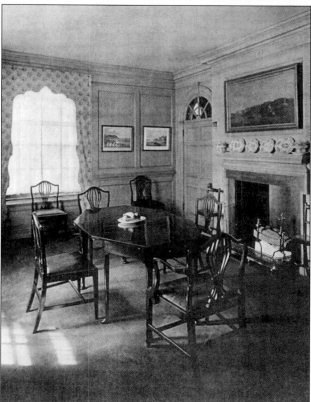

This is an inviting photograph
of the Main House breakfast
room. The family would eat
breakfast here each morning.
An outdoor awning protected
them from the glare of the rising
sun. (Courtesy Architectural
& Building Press Inc.)

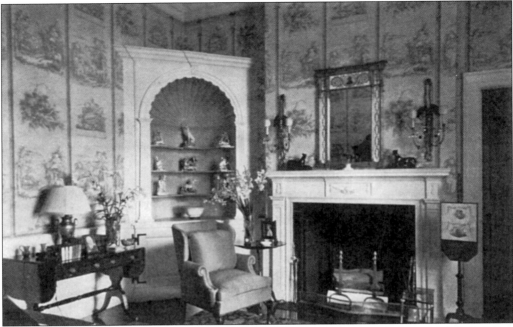

Here is a glimpse of Evelyn Field's boudoir in the Main House. (Courtesy Architectural & Building Press Inc.)

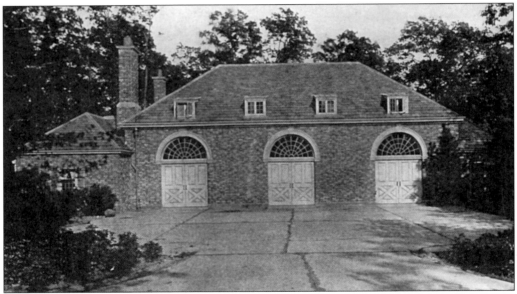

All the homes and buildings at Caumsett, from the Main House to the smallest staff cottages, were furnished with garages. The grandest of these was the Master's Garage. Designed by John Russell Pope, it was a mansion in itself, a masterpiece of Georgian architecture, complementing the Main House just to the west. On the upper level (west side) of the garage were three large bays with arched fan windows above the double doors. Guests' cars and Field's Buick hunting station wagon were parked here. At the rear of the lower level were eight garage bays, which housed the Field family automobiles. It was said that Marshall Field never visited the garage to retrieve a car. The requested vehicle was always driven to the front of the Main House for him.

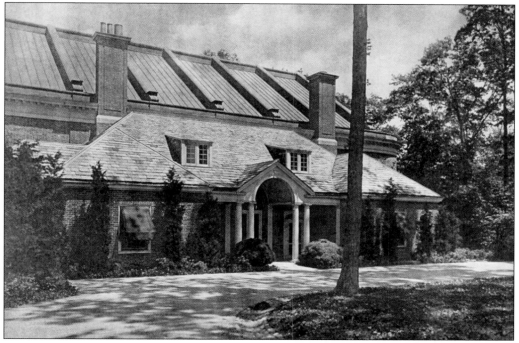

Shown here is Caumsett's indoor tennis court building. Tennis was very popular at Caumsett, among both the family and the staff. (Courtesy Architectural & Building Press Inc.)

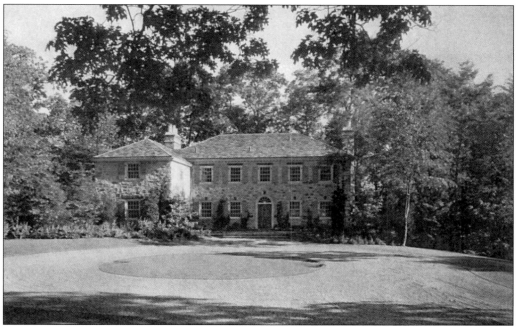

The angle of this photograph offers a front view of the Winter Cottage. It was completed in early 1926. The Fields lived here until the Main House was ready for occupancy in 1927. (Courtesy Architectural & Building Press Inc.)

This photograph shows the Winter Cottage from the garden area. The stone steps lead to the main road. (Courtesy Architectural & Building Press Inc.)

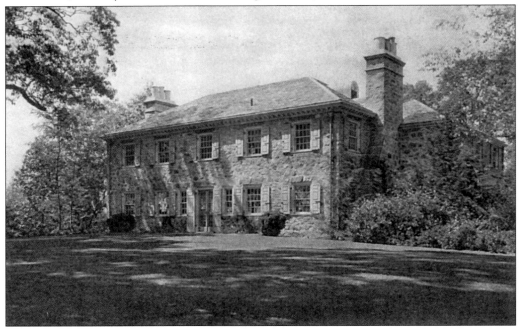

Winter Cottage guests would often walk down the rear staircase and then continue down to the shore of Lloyd Harbor. Facing west, they would usually be treated to a glorious sunset. The house was very accommodating, designed for efficient guest lodging with a large kitchen, living room, and numerous bedrooms. (Courtesy Architectural & Building Press Inc.)

The Winter Cottage is seen here in finer detail. One of the first structures built at the estate, it was the temporary home of the Field family while the Main House was under construction. (Courtesy Architectural & Building Press Inc.)

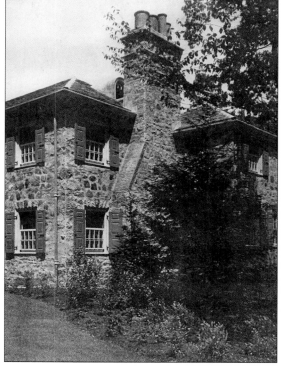

The cozy cardroom opens up in this photograph of the interior of the Winter Cottage. Card and board games were a very popular way to entertain at Caumsett, with both family members and their many guests. (Courtesy Architectural & Building Press Inc.)

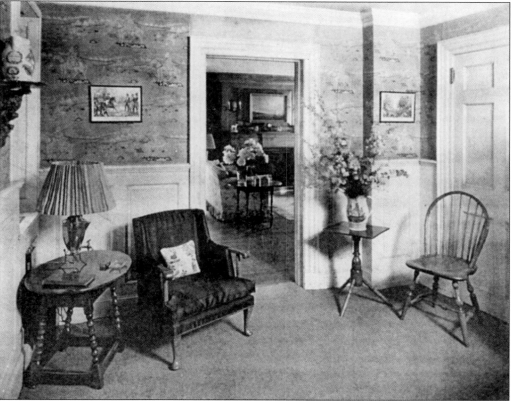

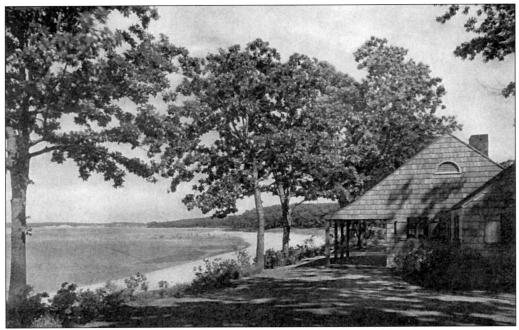

This view of the Master's Bath House looks east. Employees assigned here were Mr. and Mrs. Crush. They both wore formal uniforms when the family was present. For Mrs. Crush, and the other female staff, the uniform included high-heeled shoes. Not shown here are the saltwater pool (the only pool on the estate) and two tennis courts. Marshall Field spent a great deal of time in this area. (Courtesy Architectural & Building Press Inc.)

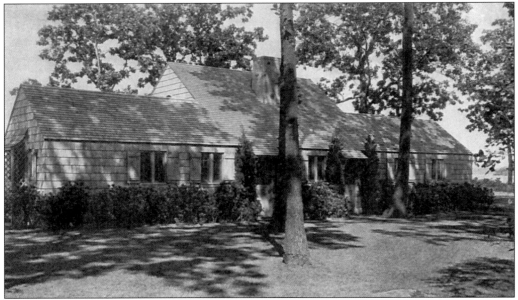

The Master's Bath House is shown here in a front view. The house consisted of three sections. The wing at left was the ladies' changing/locker/shower room. The wing on the right provided the same accommodations for men. The section at center housed a full kitchen. Behind the kitchen was a lounge with a large fireplace and fully enclosed porch facing Long Island Sound. The building had water views on three sides. (Courtesy Architectural & Building Press Inc.)

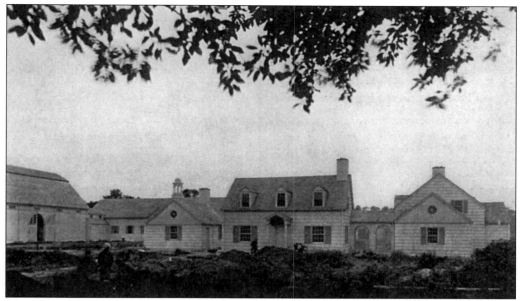

This rare construction photograph shows the Farm Group. The structures are, from left to right, the hay barn, estate office, farmer's cottage, and men's quarters. At the Farm Group complex, there were many garages to house the trucks and tractors necessary for estate work. There was a large REO truck responsible for delivering ice and milk to the estate employees from the on-site dairy on a daily basis. The REO would also be driven to Huntington to pick up and deliver dayworkers and material supplies. (Courtesy Architectural & Building Press Inc.)

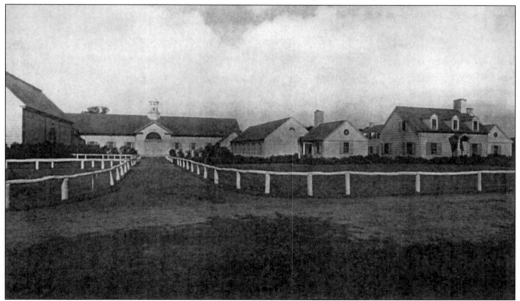

This photograph of the Dairy Barn Complex includes, from left to right, the hay barn, machinery building, garage, estate office, and farmer's cottage. Although known as the Marshall Field estate, the Lloyd Neck property was also called Caumsett Farms. This was the working engine of the estate, the operations center for the vast 2,000-acre property. A large number of employees resided here. Most of the farming activities centered on the huge, 100-plus herd of Guernsey cattle, a breed renowned for quality milk with a high butterfat content.

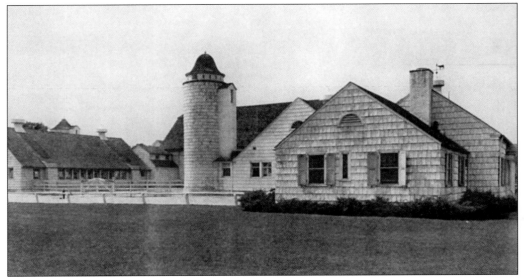

This is the Dairy Barn Complex, including dry stock, hay and milking barns, and dairy building. The cattle were under the supervision of John Spencer Clark, who was the superintendent of the entire estate. A major part of the grasslands at Caumsett was set aside for the herd. Fields of corn were maintained for the cattle as well. The grazing meadows were served by large concrete, automatic-filling water troughs for the cows. Most of these still exist on the property today, although none are functional.

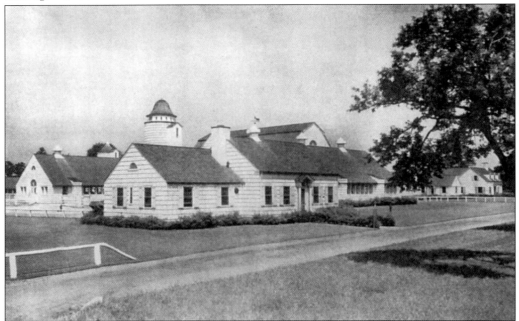

Here is a photograph of the Dairy Barn Complex and the dairy and milking stock barn. Many of the dairy products were given to the staff, both resident and dayworkers. For example, milk was distributed each day to the households. Each husband and wife got a quart each, and an additional quart was included for each child. During World War II, the estate qualified as a farm under emergency guidelines, due to its dairy operation. This allowed the purchase of gasoline and other products that were denied to other estates.

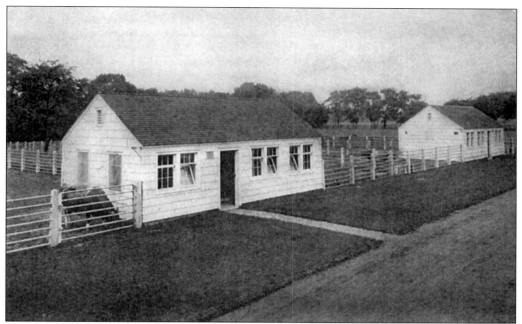

These are the bull pens at the Dairy Barn Complex. Marshall Field's prizewinning herd of bulls was kept in this area, just north of the main barn. Note the fencing in this photograph. The materials for the fencing were steel pipe and concrete, much stronger than for fencing used to keep horses and cows contained.

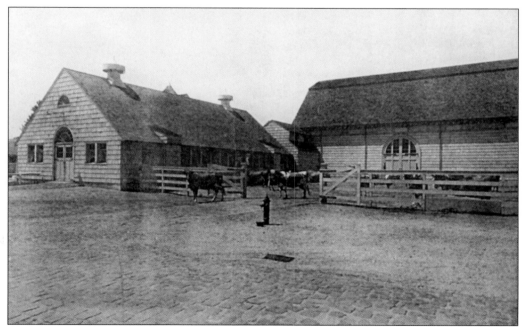

This photograph of the Dairy Barn Complex shows the dry stock and hay barns. All milking, refrigerated storage, and bottling were done on the premises. Caumsett milk was neither pasteurized nor homogenized. The cream was described as being thick and yellow. The natural bacteria found in the unpasteurized product allowed for certain cheeses and special dairy products to be created.

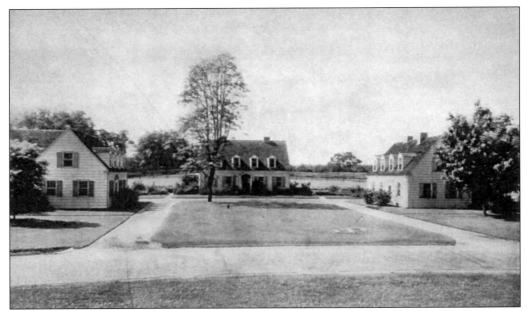

For someone entering Caumsett State Park, these servants' cottages were at the top of the hill, on the north side of the parking lot. Although they were called "servants'" cottages, Farm Group supervisors and their families lived here. There were two families in each house. Across from these cottages, in the location of the asphalt parking lot today, were complete recreational facilities for all employees, including a large playground and a tennis court. The cottages were removed after a fire in the late 1960s.

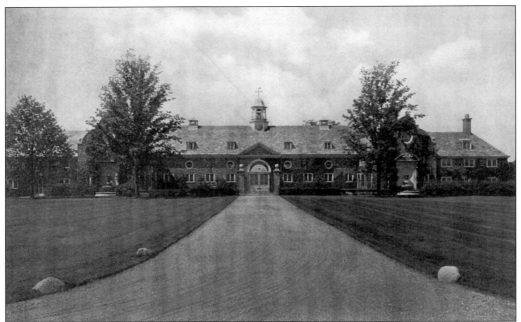

This is a front view of the Polo Barn, located on the main road to the Main House. Often, visitors to the estate would pull up to the front door here, thinking that this was the location of the Main House. They were politely given directions and sent on their way. (Courtesy Architectural & Building Press Inc.)

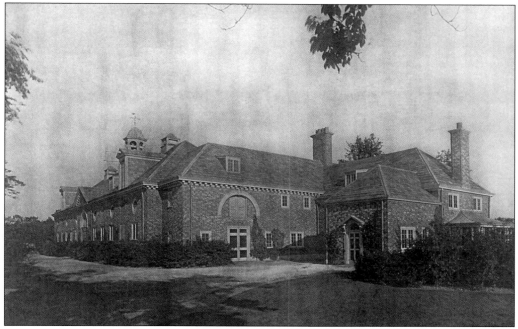

This is a rear view of the Polo Barn, looking east. The stable had 16 first-class horse stalls, one large wash stall, and a harness and carriage room. It also featured 11 tiny bedrooms for the grooms (and visiting grooms), two small kitchens, two small dining rooms, a small living room, and just one bathroom. (Courtesy Architectural & Building Press Inc.)

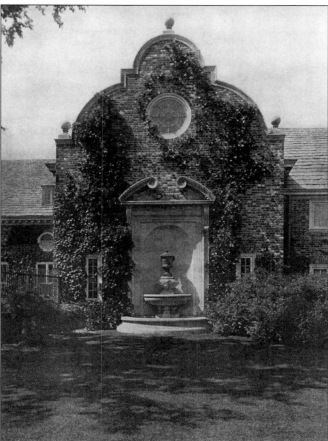

This detailed photograph of the Polo Barn shows one of two fountains. They were sought after by the estate employees for photographic purposes. A worker was not a true Marshall Field employee until he or she lay down in the fountain and had someone take a photograph. The Caumsett Foundation archives has dozens of employee photographs taken here. (Courtesy Architectural & Building Press Inc.)

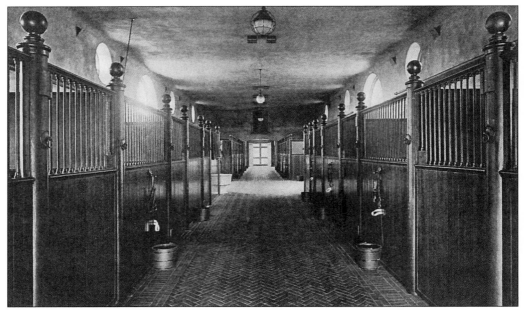

This is the Polo Barn stable area. Field's polo ponies were well taken care of. The room was ventilated in the summer and heated in the winter. (Courtesy Architectural & Building Press Inc.)

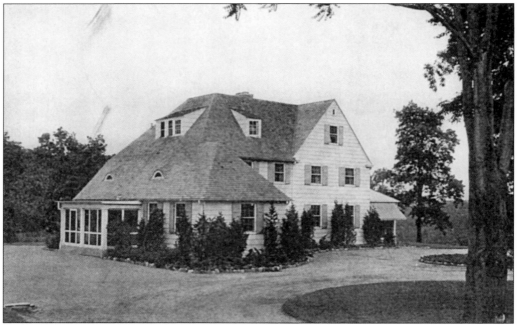

John S. Clark, the Caumsett estate manager, lived in this home with his family. It was located between the Winter Cottage and the Walled Garden. Water views of Lloyd Harbor were provided. Clark was responsible for every operational facet of the estate. Though a tremendous amount of pressure was placed upon him, he excelled at the job.

This is the Caumsett estate gatehouse. Also known as the Henry Lloyd Manor House, it was built in 1711. While it is located on property that Marshall Field purchased, he had the good sense to allow the structure to remain. The adapted home housed two estate employees and their families. The historic home is now maintained and operated by the Lloyd Harbor Historical Society, which restored the structure to its original condition.

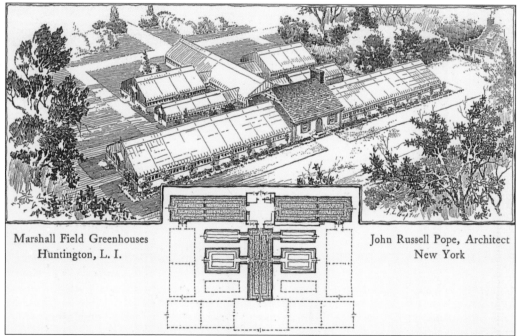

Marshall Field Greenhouses
Huntington, L. I.

John Russell Pope, Architect
New York

The renowned estate greenhouses are shown in this drawing. Evelyn and Marshall Field loved flowers and were determined to keep the Caumsett estate supplied with fresh flowers on an almost daily basis. These are the plans of glass company Lord & Burnham for the greenhouse units that would be built at Caumsett. The house in the center contained heating apparatus for the units. The outlined boxes represent future expansion plans, which were never carried through.

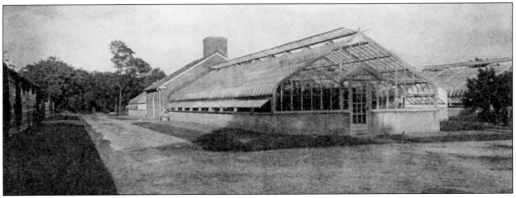

Located south of the Walled Garden was the greenhouse complex. Marshall Field's extensive array of hothouses were designed by the estate architect John Russell Pope and completed by 1926. It is said that Field did not want the ornate, glass-domed palm court greenhouses that were very much in fashion on large estates at the time. He wanted a group of glass buildings that would be both attractive and functional. In addition to the houses, there were also cold frames for raising seedlings and tendering plants. The whole complex was heated by coal-fired steam boilers that required around-the-clock supervision by staff. They had to feed the boilers and check the temperatures. An oil-fired, thermostatically controlled system would not be introduced until after World War II.

This is the home of head gardener George Gillies. Under his total supervision, the greenhouses were used primarily for the raising of flowers, not vegetables. A vast variety of flowers, including calla lilies, were raised here, many from seedlings. There was also a melon house, where fruits were suspended from netting. The flowers grown here were used to decorate the tables and rooms of the Main House and the Winter and Summer Cottages. Cut flowers were also brought to Field homes in New York City. At the Main House, there was a special floral arranging workroom near the dining room, where Gillies would artistically arrange centerpieces. Additional staff at the greenhouse also arranged flowers. All floral pieces throughout the estate would be checked daily by the greenhouse staff.

Four

BUILDINGS AND LANDSCAPES

The construction on the estate can best be described as the formation of a small town with modern infrastructure. Road, water, electric, communication, drainage, and septic systems were designed, built, and installed. Acres of forest were cleared and graded to improve views of Lloyd Harbor to the south and the Long Island Sound to the north. For example, the area behind the Main House to the fresh pond was completely clear-cut to open the vista. To the west, additional tree removal allowed a Main House view of Roosevelt's Cove. Detailed landscaping plans were drawn out and made real. Dozens of buildings from the Main House to storage barns were designed and constructed, all in a short period of time using the most efficient design, management, and construction techniques available at the time.

A modern visitor may not know that the Main House was built with full wings on its west and east sides. During World War II, the Fields lived in the Summer Cottage, while the Main House was rented to the War Department. The family grew accustomed to the smaller accommodations and, when the war was over, were in no hurry to move back. In addition, staff both from Europe and America found better job opportunities elsewhere after the war, leading to a labor shortage and rising wages. Government programs like unemployment insurance and Social Security raised payroll taxes, and property taxes were now becoming a major expense. The decision was made to remove the east and west wings from the Main House to better serve the postwar needs, related staff shortages, and rising expense levels. Despite these challenges, the charm and grandeur of the Caumsett estate itself remained just as it had been before the war.

Each of Marshall Field's three wives made her mark on the Main House and its surroundings. For example, even though Field was only married to his second wife, Audrey, for three years, she managed to completely redecorate the Main House and its surroundings. Inside, furniture and furnishings were changed; outside, thousands of colorful flowers were planted in place of existing, more formal plants requested by Field's first wife, Evelyn. Much of the initial landscaping design throughout the estate was heavily influenced by large planting coverage between recreation areas and employee walkways and service roads. This was due to Evelyn's insistence that nonessential staff working at Caumsett not be seen by the family or by guests.

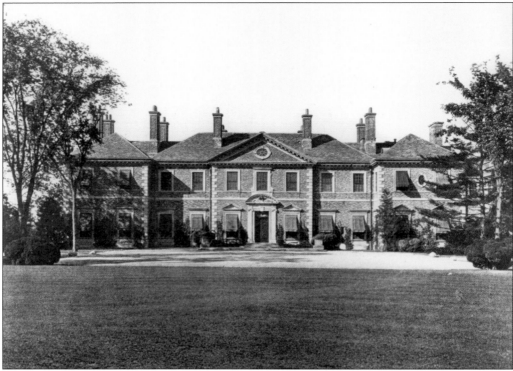

The Main House is seen here around 1930. Note the full west wing on the left, since removed. It contained a formal living room on the first floor and Evelyn Field's bedroom on the second floor. In addition, the east wing, partially seen on the right, contained three floors. Each floor had 10 servants' bedrooms. The east wing also had a large basement for laundry and tailoring services.

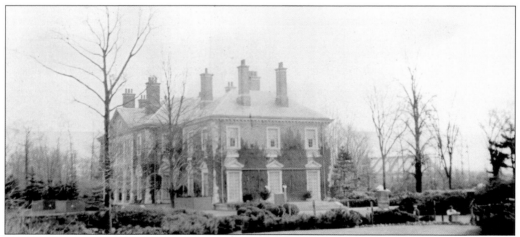

This is a rare photograph of the Main House west wing. The first-floor formal living room was used for entertaining and for the annual employee Christmas party. Evelyn Field's extensive bedroom area was above. While extensive renovations took place to repair the Main House after the wings were removed, several in the architectural field openly commented that the balance and formal stature of the home had been severely tarnished.

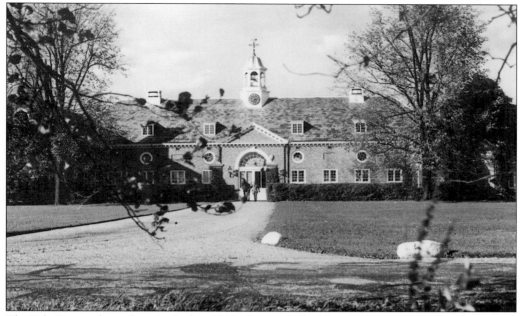

The Polo Barn is shown here in the late 1940s. Ivy on the building has been removed, and plantings have been placed in front of the fencing for privacy and to lessen the spooking of horses in the courtyard. The Polo Barn was still active at this time, but the sport of polo had been replaced with judged eventing, courtesy of Field's daughters Fiona and Phyllis, who were very talented riders. One thing remained the same: the horses were still world class. In the 1950s, numerous horse shows were held at Caumsett, with one of the Field daughters quite often winning the top prize.

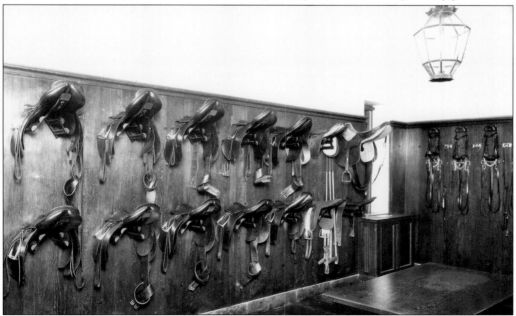

The Polo Barn tack room provides an illustration of the number of horses on hand and the meticulous condition the riders' equipment was kept in. A staff member was assigned to this room on a full-time basis and was responsible for every material component connected to the horse and rider.

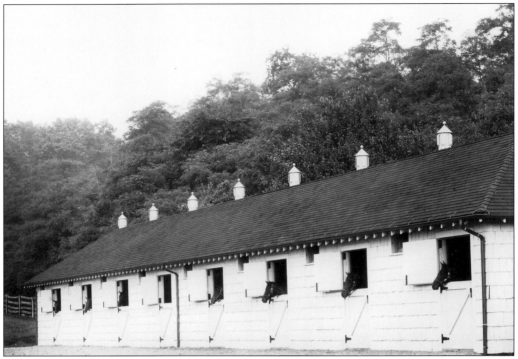

Most polo ponies were female. Male horses were housed at an additional horse and employee facility called the Visitors Polo Barn. It was built southeast of the Polo Barn and was also known as the Broodmare Barn. A broodmare is a mare kept for breeding. Polo ponies were often born here. A large house at the east end of the barn was used as living space for Caumsett grooms and visitors.

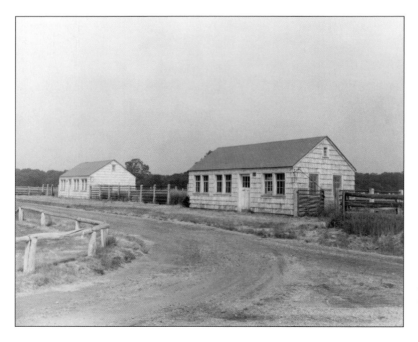

Bull pens at the dairy complex are seen here. Field's inventory of world-class bulls was kept in this facility. The infamous bull Caumsett Dynamo lived here.

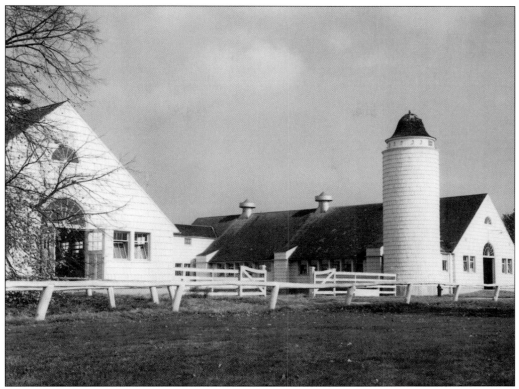

Note the height and construction of the fencing in this photograph of the Dairy Barn Complex. It was not necessary to have high fences here in the cow barn area, as cows cannot really lift their legs over obstacles. The cows would be led from here to different pasture areas to feed on the grass. In winter, they would be fed corn and hay grown on the estate. The corn was stored in the silo shown here, and the hay was kept in the hay barn (not pictured).

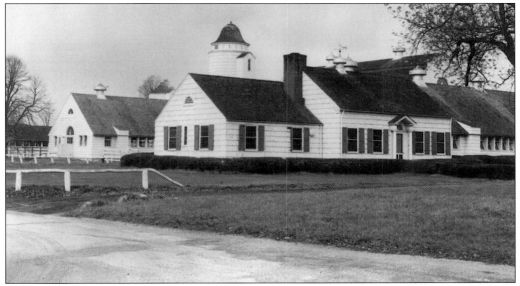

Milk bottling took place in this part of the complex. The milk was sterilized in the area directly behind the silo as shown in this photograph.

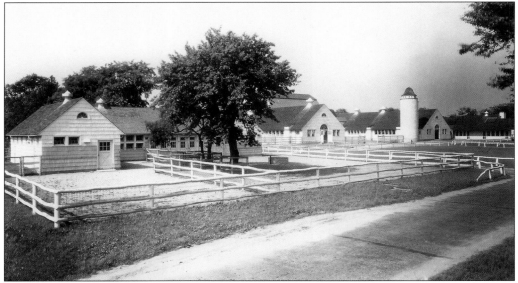

In this photograph of the Dairy Barn Complex, the calf barn is on the left. Cows gave birth in this building, and the offspring were cared for in this special needs area. The tree is near the spot of the current park visitors' kiosk.

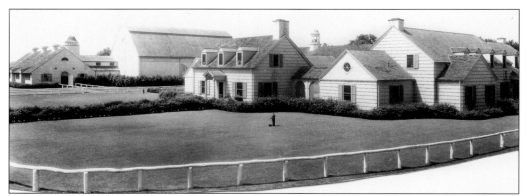

The home (center) of dairy manager Ken Berry is pictured here. This house, attached to the Dairy Barn Complex, served as the park's restroom facilities from 1976 until 2016, when new and modern facilities were opened in the former calf barn. The housing complex to the right no longer exists. It was home to single men working on the estate.

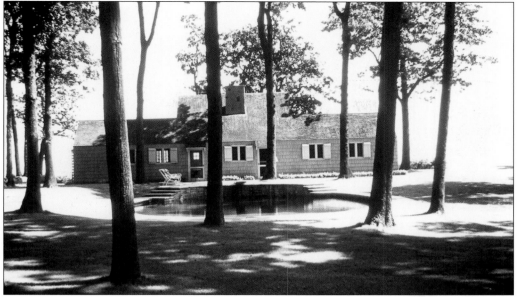

This is the Master's Beach House. Even with the estate's large, country-styled Main House, sometimes, it was nice to simply grab a book and sit in a lounge chair by the saltwater pool. Service provided by Mrs. Crush and her husband took care of everything else. The pool was constantly replenished with seawater and required a great deal of care. The pump house, a low brick building that serviced the swimming pool, is still standing. It is the only structure of any kind remaining on the Caumsett shoreline.

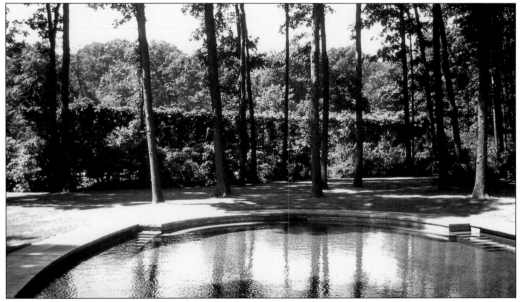

This view is looking west at the Beach House pool. Note the tall hedges. Evelyn Field was very much against allowing nonessential staff working at Caumsett to be seen by her family members and invited guests. She was responsible for placing staff housing far from that of family members and directing that extensive plantings be used to block employee walkways. These hedges are a good example. An employee walkway was located directly behind them allowing staff members to reach the house from a nearby service road.

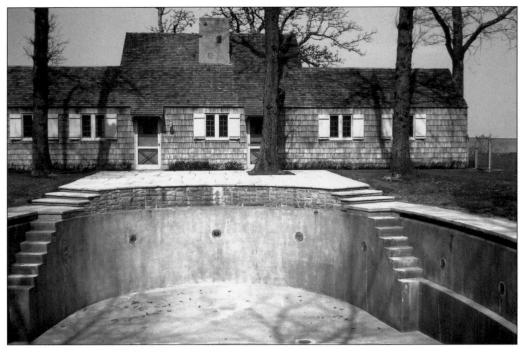

This is a rare photograph of the Master's Beach House out of season. The pool was illuminated by numerous lamps, seen in the wall of the pool. There was no filtration or heating system; a pump simply kept saltwater circulating from Long Island Sound. In late 1960, the parks department drained the pool for good and placed a wooden cover over it. Kids from the area sometimes used the pool as a clubhouse. One day, their campfire got a little out of control and burned off the cover. The state responded by tearing down the house and filling in the pool.

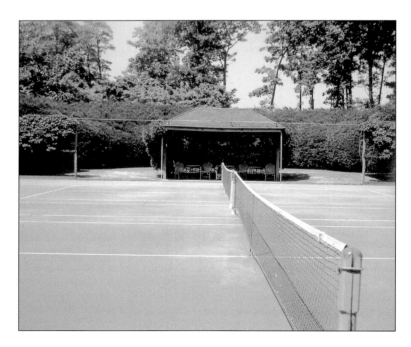

There were two tennis courts in the Master's Beach House area. Marshall Field would take tennis lessons here. He was also instructed in "yoga style" relaxation methods on the courts. Note the hedges in the background. In addition to their providing wind protection to the tennis courts, an employee walkway was located behind them.

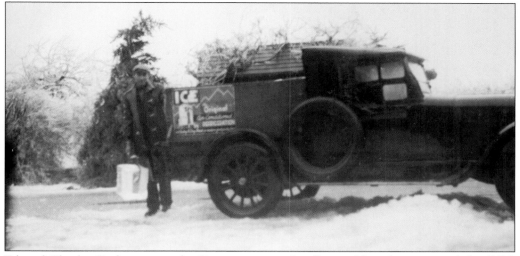

Edward Charles Gathman was the Caumsett ice and milkman. Here, he poses with his REO truck, delivering ice to the Main House kitchen via the servants' entrance. The estate sold ice and dairy products to other estates in the area and, through a third party, to retail outlets in the town of Huntington. There were two ice-making plants at Caumsett to keep up with the strong demand. In the warm months, tending the iceboxes was a major job. The icebox room in the Main House had such a tremendous melt output that a babbling brook was created and flowed gently during the warm months. This brook was put to use by Audrey Field when she "redecorated" Evelyn Field's more formal gardens.

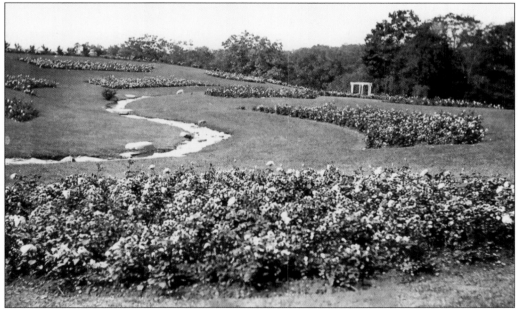

Shown here is the landscape behind the Main House in 1932. The design was by Audrey Field. A lover of colorful flowers, she had the landscaping around the Main House reconfigured for her desires. Note the "babbling brook" in the center of the photograph. Runoff from the iceboxes in the Main House kitchen fed this attractive feature. In a time before automatic irrigation, estate staff would feed water buckets from the brook, which wound its way down the hill to the fresh pond.

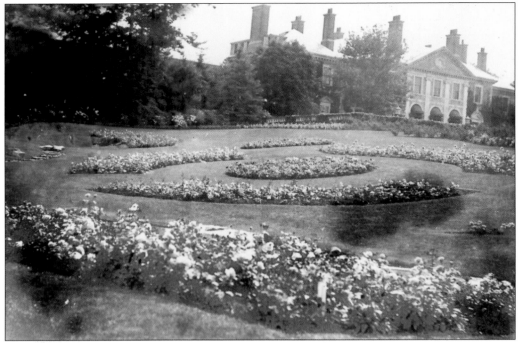

This is another view of the Main House landscape, this time looking up from the hill toward the Main House. Married for only three years, Audrey Field made her mark on the estate. Inside, furniture and furnishings were changed; outside, thousands of colorful flowers were planted in place of existing, more formal plants installed by Field's first wife, Evelyn.

This is the beautiful Main House Long Garden. At left is the Main House, with the original west wing.

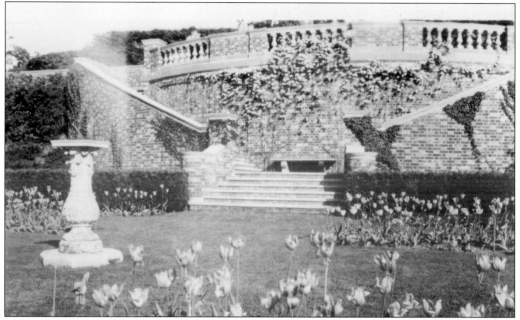

Marshall Field requested that a saltwater pool be built at the bottom of the Long Garden staircase. Engineers, however, could not design an efficient pumping system to bring the saltwater up from the Long Island Sound. It was decided instead to build a concrete pool near the sound, at the Master's Beach House. The view from the top of the staircase was magnificent.

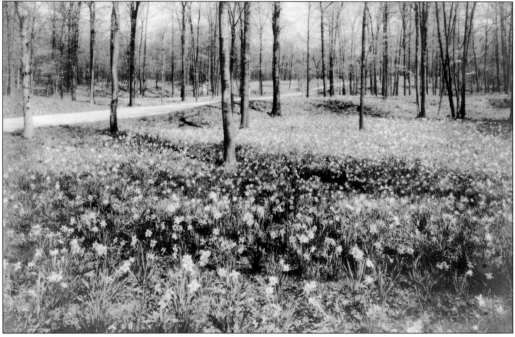

Shown here is a beach access road, just west of the Main House. A frequent area of visitation by Evelyn Field, the area was blanketed with daffodil bulbs. This is still true to this day, making a walk down Beach Road a sight to behold each spring, when the daffodils once again announce that winter has come to an official end.

A landscaped staircase ran behind the Winter Cottage. It leads to the Main Road and was used by guests and staff for travel between the Winter and Summer Cottages.

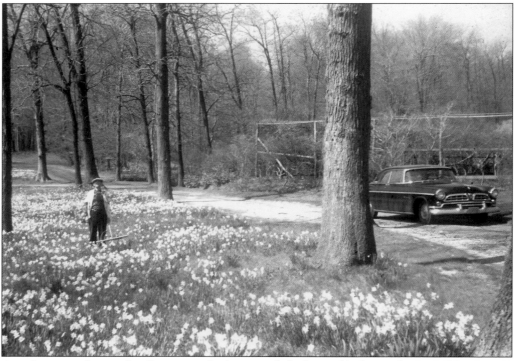

A worker is seen here with a Caumsett vehicle, most of which were black, two-door cars. His presence near the Master's Beach House implies that no family members or guests were in the area.

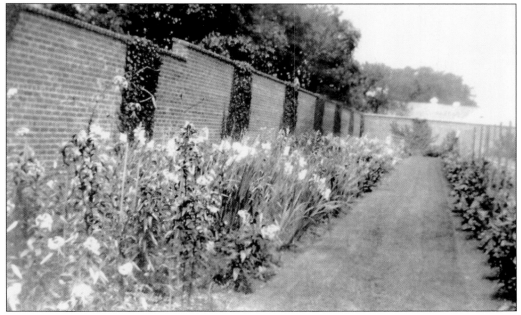

The four-acre Walled Garden was the agricultural center at Caumsett. It was here that vast quantities of vegetables, fruit, and flowers were grown. The high brick walls protected the products from destructive winds and animals and also captured heat from the sun needed for proper plant growth. Within its walls could be found rows of carrots, beets, celery, cabbage, cauliflower, string beans, and peas. The garden was famous for its blueberries.

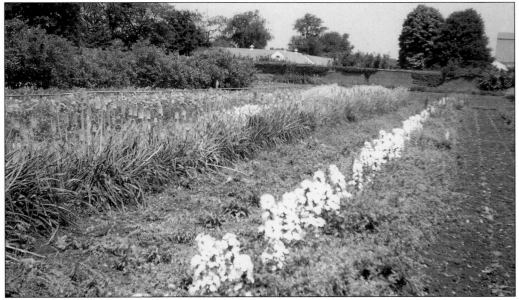

In addition to vegetables, there were grapes, pear trees, and beds of cutting flowers. Several men were employed to tend, cultivate, and harvest these plants. Despite being a functional garden plot, it was meticulously maintained and was as attractive as any decorative yard. Everything was planted in an orderly and linear pattern. The soil was weeded, hoed, and aerated. An overhead piping system provided the necessary irrigation. Just outside the garden, and on other parts of the estate, there were apple and peach orchards.

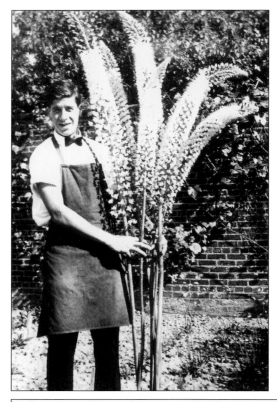

Marshall Field liked to win at everything he did. He ruled the major indoor flower shows in New York, Maine, and Chicago. Under his strict guidance, Caumsett Farms won awards too numerous to mention. George Gillies specialized in unique plants that would be noticed and sought after. The plant shown here is one of the multi-award-winning calla lilies.

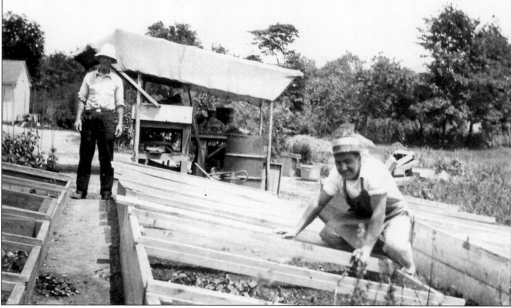

Caumsett farm employees install starter plants near the work shed on the south side of the greenhouse. The wood boxes made removal of the fully grown plants much easier. Behind the worker at left is the enclosed potting area where the young plants would be transferred to pots filled with dirt for distribution around the estate, or sent inside the greenhouse area for additional and rapid growth under constant care.

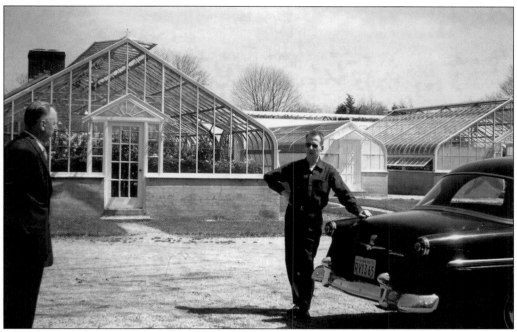

George Gillies (left) confers with a staff member in the greenhouse area. To the south of the garden lay an extensive greenhouse complex, which still stands today in a state of radical disrepair. It is protected by landmark status. Interestingly, head gardener Gillies always wore a jacket to work—even on the hottest days. He was meticulous in the way he carried out his job functions.

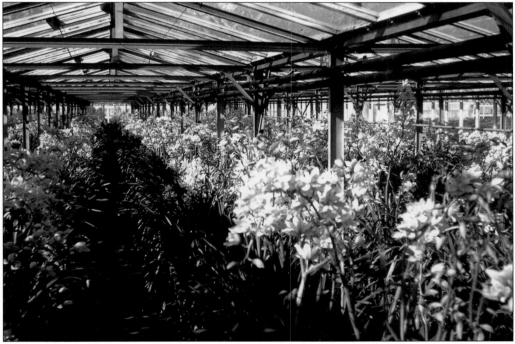

This is a stunning view of the long wing of the main greenhouse. As evident here, this was a busy and well-maintained part of the farm group. The flowers grown here were used all over the estate and in Field's New York City homes. Leftover product was offered to retailers and wholesalers.

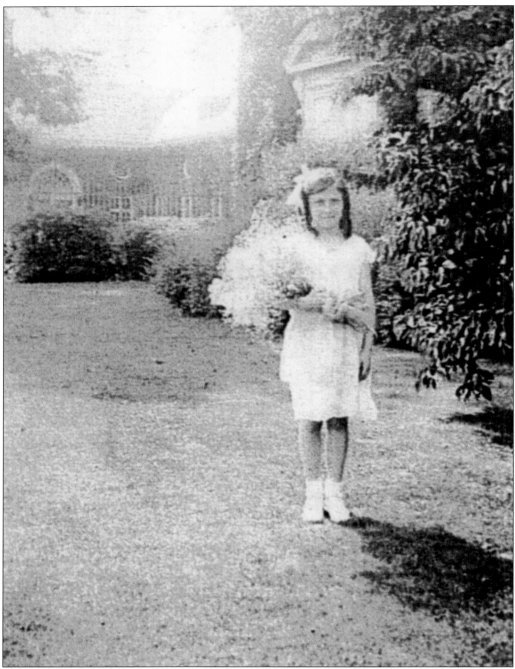

This is Gwen Fayers, daughter of Polo Barn and Summer Cottage workers. She took piano lessons from another estate employee, who thought it would be nice for Gwen to give a formal recital. Invitations were sent to other staff members, and dozens of people showed up at the Summer Cottage on a Sunday afternoon. One of those was George Gillies, who presented Gwen with a large bouquet of flowers after her performance. The staff members in the Caumsett Farm Group were very close with each other, as were the staff in the Main House. However, the two groups did not interact on a social basis.

Five

CAUMSETT FACES ADVERSITY

Caumsett was hit hard by two events in the late 1930s and mid-1940s. One was caused by nature, and one was the work of man. The Great Hurricane of 1938, also known as "the Long Island Clipper," hit Caumsett as a Category 3 storm at 10:00 p.m. on September 21. Field had sent most of his employees home and took shelter in the Winter Cottage. Those remaining who were in harm's way were sent to the Henry Lloyd Manor House, as the hill north of the house afforded a great deal of protection. The storm hit Caumsett hard and did immense damage to the property and to some of the employee homes. Hundreds of trees were felled on the property.

Alfie Kuntz remembers the night:

My family and I were living in the Engineer's Cottage at the time [house on immediate left entering the current park], and we watched as the water level in Lloyd Harbor continued to rise by the hour. At about 10:00 p.m., the water was at our front door. My dad and I stayed up all night rearranging sandbags around the coal door and trying to keep the storm drains open. We heard the cracking of trees all night. It was terrifying. The next morning, Marshall Field sent every person he could spare to help the Village of Lloyd Harbor get their roads open, and then we began what would be ten to twelve weeks of clean up at Caumsett. The damage was amazing, but thankfully, no one was hurt.

On December 4, 1941, Marshall Field's new newspaper, the *Chicago Sun*, was printed for the first time. It would face its first real test three days later. The owner and staff at Caumsett also responded to the declaration of war, but in different ways. Field leased the Main House and area buildings to the government for $1 per year, and he gave his yacht to the Navy for submarine patrol duty on Long Island Sound. Employees either helped at Caumsett or went off to join the armed forces. Of these workers, two men, the son of the estate superintendent John Clark and the son of head gardener George Gillies, would not return. Clark was killed in an airplane crash, and Gillies died in an attack by German planes in France.

Marshall Field III probably could have called in a favor to keep his son Marshall Field IV safe at home, but that was not to be the case. Like his father did in World War I, Marshall Jr. joined the armed forces, signing on with the Navy in August 1942. Stationed as a gunnery officer aboard the aircraft carrier *Enterprise*, he participated in every major naval engagement in the South Pacific. In October 1942, the *Enterprise* was at the center of the Battle of the Santa Cruz Islands. Field's conduct earned him the Silver Star and the Presidential Unit Citation. A later battle earned him a Purple Heart. He left the military after the war at the rank of lieutenant commander.

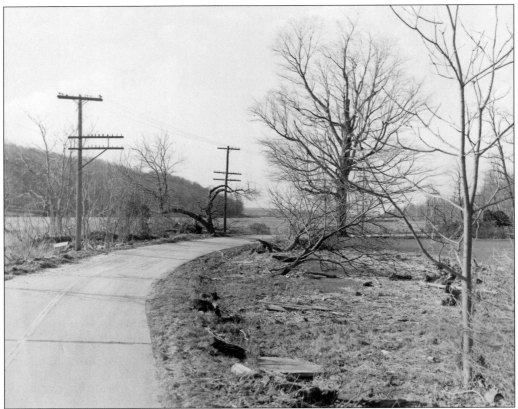

Lloyd Harbor Road is shown here in September 1938. Usually, the trees shown would still have leaves at this point in the season. Note the height that Lloyd Harbor reached, indicated by the debris on the lawn of the Henry Lloyd Manor House.

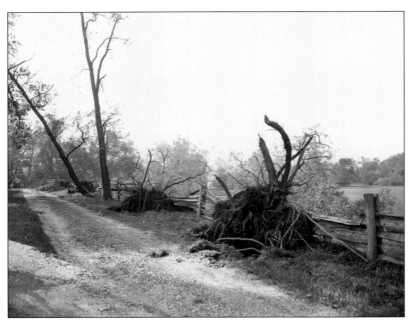

Seen here is hurricane damage near Fisherman's Road. The storm took Long Island by surprise—initial weather report warnings were later downgraded. More than 60 people would perish and thousands of homes and businesses were damaged or destroyed by the storm.

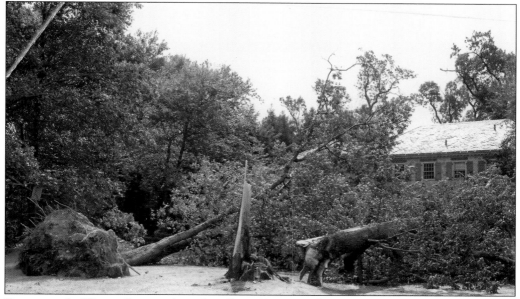

Trees near the Winter Cottage show the effect of (estimated) 120-mile-per-hour winds. While the structure was left untouched, landscape damage in this area was extensive.

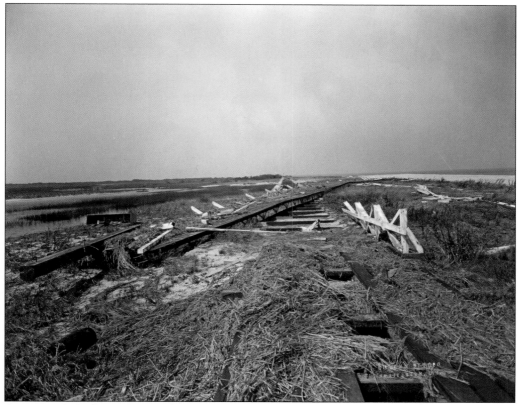

Sections of Plank Road washed out to Long Island Sound during the storm. The road ran from the present-day fisherman's parking lot to the estate dock near the "sand hole" at Lloyd Point.

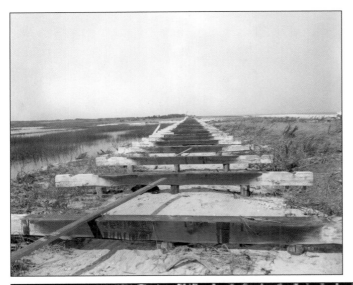

Marshall Field sent a one-paragraph note to estate manager John Clark immediately after the storm: "Visit Lloyd Harbor authorities and help where necessary. Repair Caumsett damage only when appropriate to do so." Shown here under construction is the new, raised Plank Road.

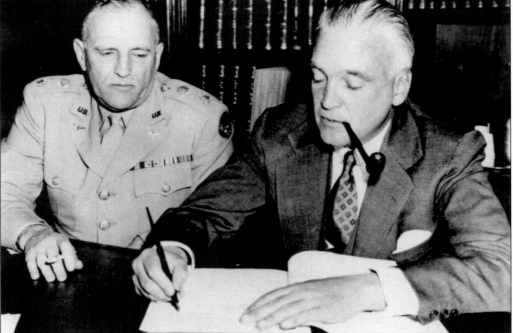

In the spring of 1942, Marshall Field (right) leased most of Caumsett to the US Office of War Information for use as a technical training ground for $1 per year. Field and his family moved into the Summer Cottage. The Farm Group continued to operate independently, with one notable bonus. Because it had prewar registration as a farm, it was not subject to gas or material rationing. During World War II, with food shortages and imposed rationing, Caumsett mobilized in its own way by raising beef cattle, chickens, and pigs. The cattle were able to graze the vast acreage used by the dairy cows and share in the winter stores of hay and corn. The pigs were penned at the west end of the estate, being afforded a spacious field and woodland area in which to roam. Butchers were dispatched to the estate to slaughter and dress the animals. Other estates in the area, not having Caumsett's farm classification, had a very difficult time staying operational during the war years.

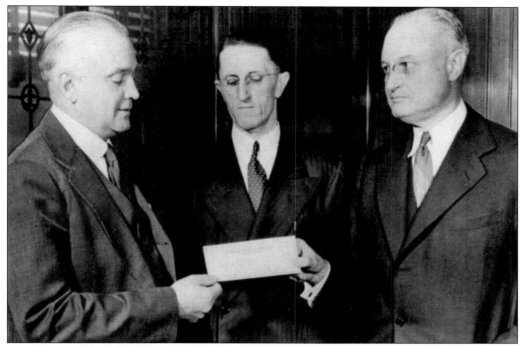

A representative of the armed forces presents a check for $1 to Marshall Field (left) for the rent due in 1942. Why $1? Should Field have simply turned over the estate for free, tax payments to the Town of Huntington and the Village of Lloyd Harbor would have been suspended, causing immediate financial hardship for each. Field sought to avoid harsh publicity by electing to receive a token payment from the government and continuing the payment of local taxes.

The subject of this 1942 press conference in New York City was the sale of war bonds. Sitting at the desk on the left is New York City mayor Fiorello La Guardia. Eleanor Roosevelt is seated next to him. Over time, Marshall Field (standing at left) and Roosevelt would become good friends. He was an initial and strong backer of many of her social commitments.

During World War II, in addition to buying millions in war bonds, supporting Roosevelt's agenda, and touring with the USO, Marshall Field did even more. In reaction to the German nighttime bombing raids on the city of London, it was decided to evacuate women and children to the best possible extent. The English-raised Field implemented programs to expedite this process in the United States. He is shown here at a New York City dock welcoming new arrivals to safety.

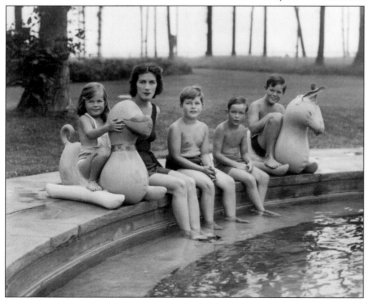

The Drummond family were personal friends of the Fields from England. Mrs. Cyril Drummond and her children were immediately invited to live at Caumsett and spent the duration of the war at the Summer Cottage. The children attended public school. Seen here are, from left to right, Annabelle, Mrs. Drummond, Maldwin, Aldred, and Bendor.

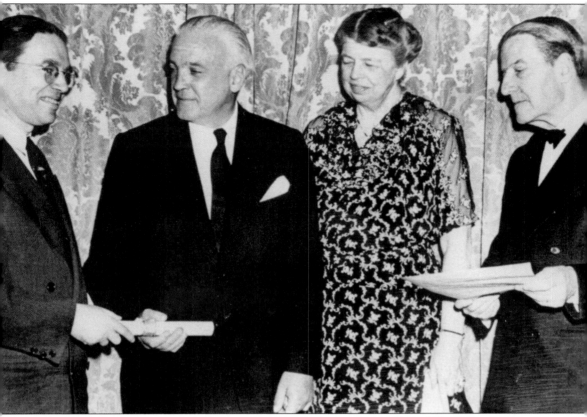

Marshall Field III (second from left) accepts a commendation from a United Nations executive. Eleanor Roosevelt is to his left. Field was an initial and substantial financial contributor to programs initiated by Roosevelt during and after her time in public office. For example, the two worked side by side on the government's 1941 European Refugee Program, with Field providing both support and financing. Roosevelt and Field would become good friends in the years that followed.

Marshall Field (seated, second from right) celebrates with returning veterans after World War II. He would often take a personal stance regarding the various problems faced by returning vets, and he worked hard to help get them the benefits and rights he thought they deserved. Field had worked his way up in the military ranks, from private to captain during World War I, where he saw action in France. He knew what some of these men had been through, and what they required to reenter society.

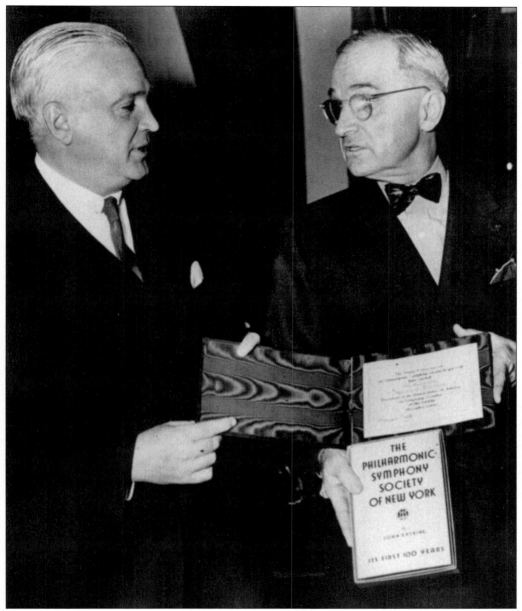

This is a classic photograph of Marshall Field (left) with Pres. Harry Truman. Field was a major sponsor of the Philharmonic Symphony Society of New York and served as its president in the early 1940s. Truman and Field shared a love of classical music.

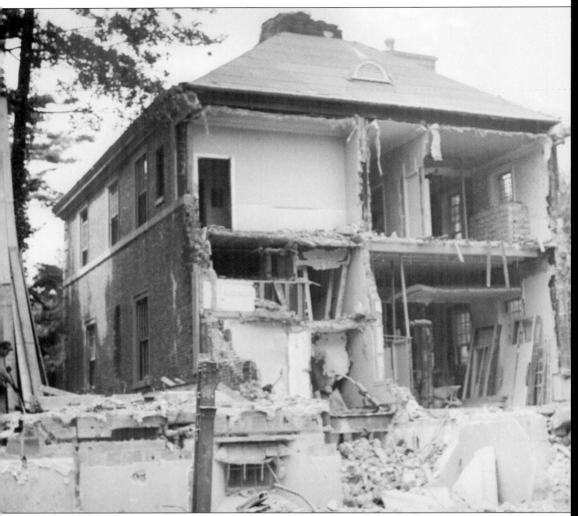

At the end of World War II, the world had changed. Tens of thousands of troops would return home, eager to make up the years they lost while away. They were hungry, and they were proud. They were not coming back to garden, milk cows, and groom polo ponies at Caumsett without a major pay raise and even better living conditions. They were easily getting new jobs and moving to the Levittowns across the United States. New laws were passed and were now in effect. Social Security, unemployment, disability, and other taxes were added to the budgets at Caumsett. Even one of the richest people in the world knew it was time to cut back, a feeling reinforced after spending the war years living in the Summer Cottage. The Fields decided to reduce the size of the Main House. Secret plans were drawn up in 1948 by the architectural firm O'Connor & Delaney. They involved removing the east and west wings and reassigning the numerous first-floor visiting staff bedrooms into servants' quarters. The finished product was universally panned, as the house now appeared out of balance. Ruth, Marshall, and their family made plans to move permanently to the Summer Cottage.

Six

RECREATION AND EDUCATION

Polo matches and other equestrian activities were central to life early on at Caumsett. Foxhunting was also in vogue, and the Fields had not only foxes, but kennels full of hunting dogs. The Caumsett polo years came to an end for Field due to an injury suffered in 1936, but many equestrian events continued. The focus shifted from Marshall to Phyllis and Fiona. The Field sisters were excellent riders, due to not only the superb facilities at Caumsett but also the encouragement of their parents.

In addition to professional horsemanship, Caumsett was a place of recreational horseback riding. John Spencer Clark, estate superintendent, would make his evening rounds on horseback. Staff members recalled Clark receiving an early morning telegram in 1943, getting on his horse, and not returning for hours. He had just been notified of the death of his son John Spencer Clark Jr. in World War II.

Tennis was also a popular pastime. The grand indoor tennis court just south of the Main House provided an interior space for the game. There was also a viewing gallery, where spectators could sit in comfortable chintz-covered chairs and watch a tennis match while being served sandwiches, pastries, and drinks. The indoor court had two full-time staff members, one for food prep and one for general maintenance and lessons.

Caumsett was also a place of learning. A winding dirt path northeast of the Henry Lloyd Manor House takes visitors to an old foundation made up of broken concrete. It is all that is left of the Lloyd Neck School. Hasket Derby gave the land to the Common School District in early 1904; a one-room schoolhouse, constructed by the residents of Lloyd Neck, opened in 1908. It was warmed by a small stove inside and featured a small outhouse in the rear. Water was supplied by a hand pump near the front steps. A single teacher taught the children. Initially accommodating all grades, the school was restricted to the elementary level by 1923. Children came from private homes on Lloyd Neck and from the employee homes on the Caumsett estate. The school was made obsolete by a modern building erected on School Lane in 1934. Marshall Field purchased the property in 1935 for $1,500 and had the old school building torn down.

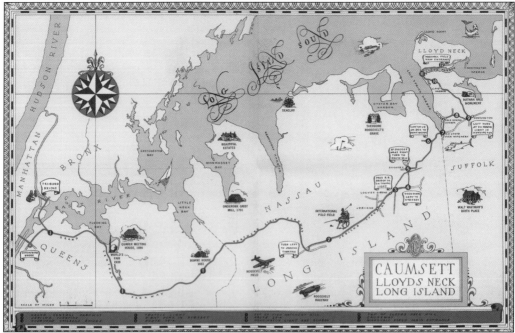

By the late 1920s, Caumsett was everything Evelyn and Marshall Field wanted and more. It was now time to share their showplace with other members of their social class. What better way to direct people to a place called "Lloyd Neck" than this fun and colorful map? For years, it was sent with invitations, both formal and casual.

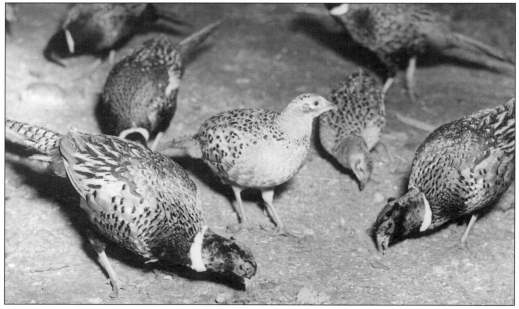

The premier sporting activity at Marshall Field's estate was hunting, which always took place in the fall. Caumsett was famous for its pheasant shoots. Providing for these aristocratic pastimes required expert landscaping and logistic skills. In order to have well-executed and "proper" hunts, much work would have to go into the planning and details of the landscape. This work was entrusted to head gardener George Gillies and gamekeeper Douglas Marshall.

76

Gamekeeper Douglas A. Marshall is shown here feeding the pheasants. The ring-necked pheasants were raised from eggs by Marshall. Pheasant shoots occurred from late September through mid-November and were the sporting highlight of the year at Caumsett. Marshall was responsible for the pheasant shoots, brooder houses, the dogs, and their kennel. He lived with his family at the Farm Group. In the early 1950s, Marshall's son Douglas Jr. took over the job when his father retired.

Between 5,000 and 6,500 birds were prepared each year for shoots. Feed hoppers were placed throughout the woods to keep the birds on the property. Beaters were employees whose job it was to drive the pheasants into the fields and swells. The birds would take flight, and Marshall Field and his guests would take aim. This event most often took place north of the Polo Barns in the large open field.

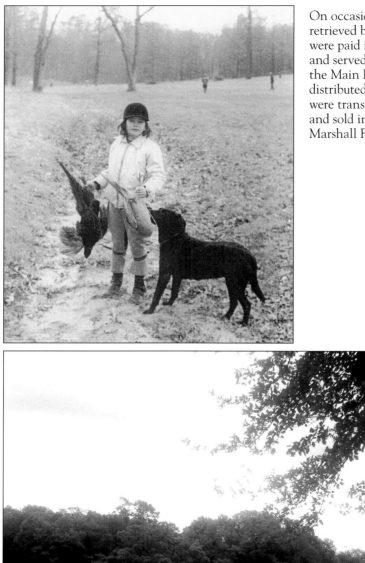

On occasion, the dead birds were retrieved by estate children (who were paid in candy), hung to dry, and served to dinner guests at the Main House. They were also distributed to the staff. Excess birds were transported to New York City and sold in markets. Shown here is Marshall Field's daughter Fiona.

In this 1954 photograph of a fox hunt, note the television camera with the CBS logo. The Field family loved to make films of their adventures at Caumsett and of their travels around the world. This filmed event may have been arranged for the Fields by the famous CBS newsman Edward R. Murrow, who was best friends with Marshall. Under state ownership, Caumsett has been used as a setting for numerous television shows and movies, including *Mildred Pierce*, *Royal Pains*, *Salt*, and, of course, *Arthur*.

As the hunt proceeded, the bright flashes of red coats on horseback and packs of hounds could be seen in pursuit of a fox. The hunt ended when the fox was either caught or lost by the hounds. On a successful day, the tip or "brush" of the fox's tail was clipped off as a memento and awarded to the successful shooter. This was an integral part of this most important autumnal activity.

Estate staff members are either preparing guns or trying their luck at skeet shooting. Clay pigeons were launched from the shed in the rear, and the shooter, standing on the ramps, would attempt to bring them down using a shotgun. The children of estate workers would retrieve the missed targets, returning them to the Main House butler, who would pay them in candy bars. George Gillies's son Billy is shown on the right in this photograph. He would be killed in World War II, the second staff family member to perish.

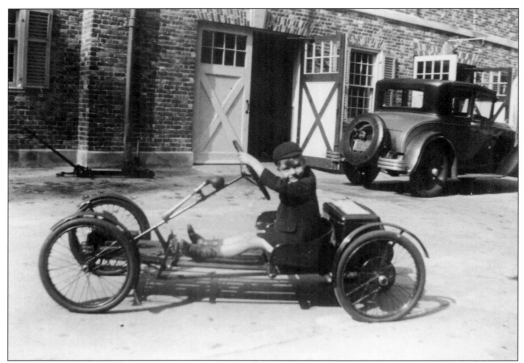

Another popular sport involved auto racing, sort of. Seen here is one of the famous Red Bugs, or electric go-karts. There were quite a few of these, and they were loved by family members, visitors, and estate workers' children. Shown here is Albert Edward "Buster" Risebrow Jr., the son of the head chauffeur. The family car is shown in the background. The Risebrows would often load up the car with estate kids and motor off to Jones Beach, where they would enjoy the rock-free beach sand and a very rare occurrence: lunch in a restaurant.

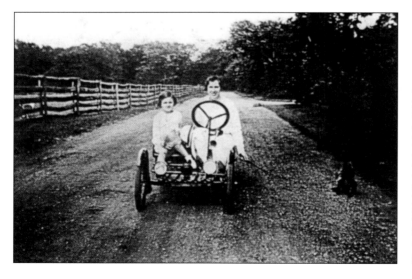

Bettine Field and her nurse Dorothy are seen aboard a Red Bug. Dorothy went wherever Bettine went, near or far. Years later, Bettine sought out her whereabouts and made sure she was comfortable in retirement.

Marshall Field IV, known as "Junior," is at left, posing with a friend around 1920. Note the polo stick in his hand. The younger Field was an excellent polo player.

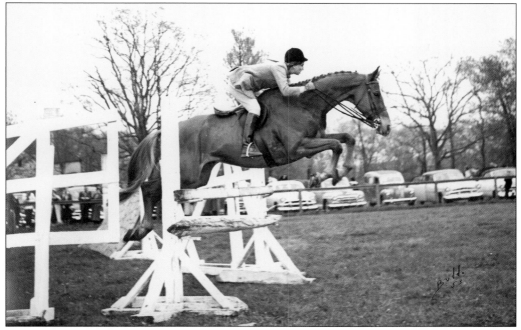

Fiona Field takes a jump at a Caumsett Farms horse show. The girls were excellent riders and took part in Field-run horse shows in the early and mid-1950s. The shows were officially sanctioned, and thus judged by qualified horse-show people. The Field girls were usually among each show's top performers.

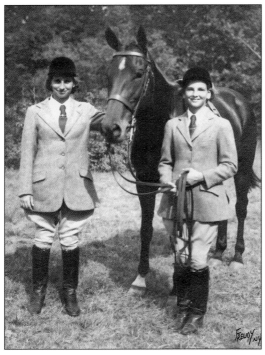

Phyllis (left) and Fiona Field pose with a horse in 1955. It is impossible to overstate how important horses were in the lives of Field family members. Marshall Field III grandchild Barbara Bliss remembers: "When it was my turn to spend the night, I usually stayed with Fiona. She was a very good rider and we would ride her ponies in the professional ring. The ring was set up to practice for horse shows with all the required jumps and hedges. I wasn't advanced enough to keep up, so I followed Fiona around on the outside path of the ring and watched as she took the jumps. Other times, we would go to the kennels with the house springer spaniels and let the hunting dogs out for a run. On one particular weekend, I remember following the gamekeeper as he set up the blinds for the weekend pheasant shoot. He once even set up the skeet traps for me, but I couldn't bring myself to pull the trigger."

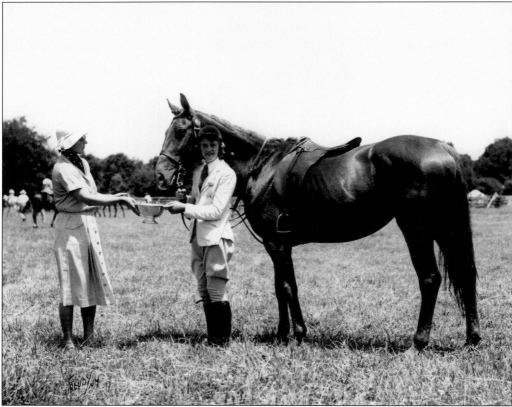

Ruth Field (left) hands Fiona Field an award at a June 1955 horse show.

Anyone who owns a horse trailer will find the pristine condition of the Caumsett horse van something to admire. The man in the door opening with the hat is Lou Back. He was the head trainer for all equestrian operations at Caumsett and personally instructed Phyllis and Fiona (seated at left). Sitting next to Fiona is Samuel Claydon, the master of the Equestrian Group who was also responsible for polo and horse-racing operations. The van often traveled to the summer races at Saratoga. When racing at Saratoga, Marshall Field allowed the workers' families to accompany their family member. Field paid for all expenses, such as housing and race-ground meals for the entire family. It is no wonder that he was greatly admired by his employees.

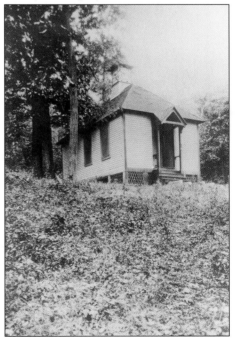

Lloyd Neck School is seen shortly before it was torn down in 1935. Alfie Kuntz remembers visiting the empty building with friends, playing at the desks and writing on the blackboard. "The door was unlocked, the windows were broken, and the desks still had the inkwells in them. It was a great place to play!"

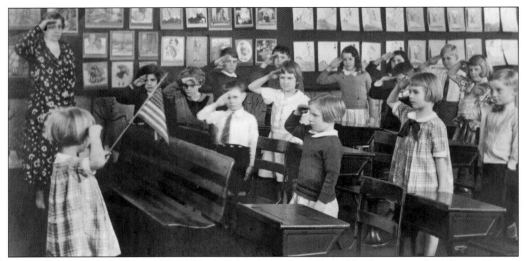

Shown here is a 1931 class at Lloyd Neck School. As remembered by former student Gwen Fayers, the photograph depicts the following: "Miss Davis, teacher. Flag holder was one of two sisters; name not known. Girl and boy with frizzy hair were from Russia, spoke limited English. Van Olstran boy, boy with white shirt and tie unknown. Van Olstran boy (brothers). Girl in white was the policeman's daughter. Girl in front with dark sweater was Dolly Marshall, the gamekeeper's daughter. Continuing left to right is Muriel Clark, the estate superintendent's daughter. Me (Gwen Fayers) and a little boy are half hidden. The flag bearer's sister is next in the checkered dress. In the rear are Billy Gillies (killed in World War II), Mildred Gapin, and Walter Hansen. We were all present that day, you are looking at the entire school! That morning our subject of the day assignment was kite-flying, as you can see by our efforts hanging on the wall!"

As remembered by Alfie Kuntz, the people shown here in 1936 are, from left to right, (first row) Fraiser Sammis, Alan Pike, James Wilde, Dorothy ?, Anna ?, Bob Berry, Bobby Kenard, and Alfie Kuntz; (second row) teacher Charles Titus, Cynthia Whitehead, Joan Regan, Patricia Ford, Dolly Marshall, Susan Pike, Karl Ericson, Waldrin Phillips, and Phil Regan. Behind the group is the one-year-old Lloyd Harbor Elementary School. Built in just six months at a cost of $75,000, it had about 25 students at this point. Almost all of the Caumsett employees' children ages 5 to 13 now attended this school.

Seven

WORKING THE ESTATE AND DAIRY FARM

The Farm Group barns at Caumsett were the crown jewel of the seemingly utilitarian complex. This area, comprised of dairy barns, a bottling plant, garages, workshops, homes, offices, and a hospital for ailing cattle, was the primary "engine" of the Marshall Field estate. It was here that the mundane operations and transmissions that kept Caumsett functioning took place.

In the milking barns, the herd assembled for the daily milking. The process was done by hand until the mid-1940s. Employee children would perform this process, for pay, up to three times a day. After the milk was collected, it was carried to the bottling plant next door, brought upstairs, and poured into a large vat, where it was sterilized. The "hot" raw milk then trickled over refrigerated rods and, when sufficiently cooled, was deposited in the milk bottles below. Bottled and capped, the milk was stored in a refrigerator at the plant. Not pasteurized or homogenized, the Caumsett Farm milk was renowned for its thick, spoonable cream, which filled the neck of each bottle.

Of course, this premium milk could not have been produced without "premium" cattle. The Caumsett herd, comprised of more than 100 registered Guernseys, was famous for its high quality. The best-known members of this herd were Caumsett Dynamo, a bull, and Caumsett Ida, a prize cow. In the days before artificial insemination was standard procedure, bulls were kept in the bull pens for the sole purpose of maintaining the stock. Caumsett Dynamo, renowned for his pedigree, was featured in Borden's dairy pavilion at the 1939 New York World's Fair as "Elmer," the "marketing husband" of the more famous "Elsie."

Caumsett Ida was one of the greatest Guernsey milk producers of all time. Under official supervision, she produced over one million pounds of high-butterfat milk in less than five and a half years. She produced twice her weight in milk a month, a feat almost unheard of in the industry. Both animals were buried on property behind the hay barn. Their grave area is marked with a granite tombstone.

In the early days, draft horses were used for some of the mechanical work—the grading of roads and plowing of fields being their main functions. Close to the current park manager's office, there was a weighing station. All deliveries of coal, hay, and fertilizer had to be weighed by the estate staff before they could proceed onto the property.

The area was also a residential center for estate employees, with several houses, including three large family dwellings at the top of the Service Drive.

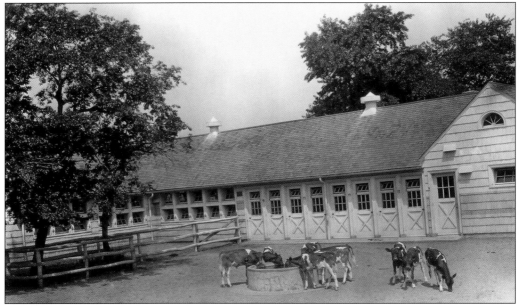

Seen here are newborn calves at the Calf Barn. Marshall Field's employees took exceptional care of his valuable livestock. The animals were known nationwide for their quality.

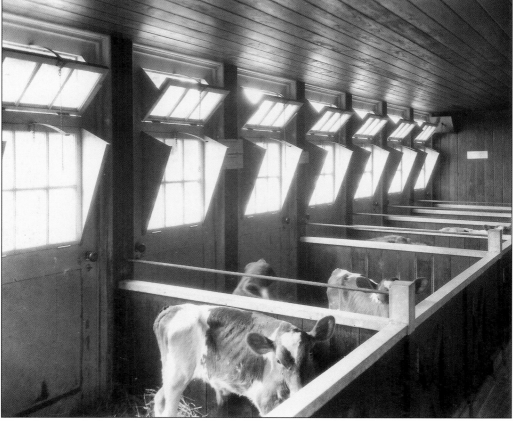

This photograph shows the interior of the Calf Barn.

These calves in the Calf Barn were very well cared for. A long life for most was the end result.

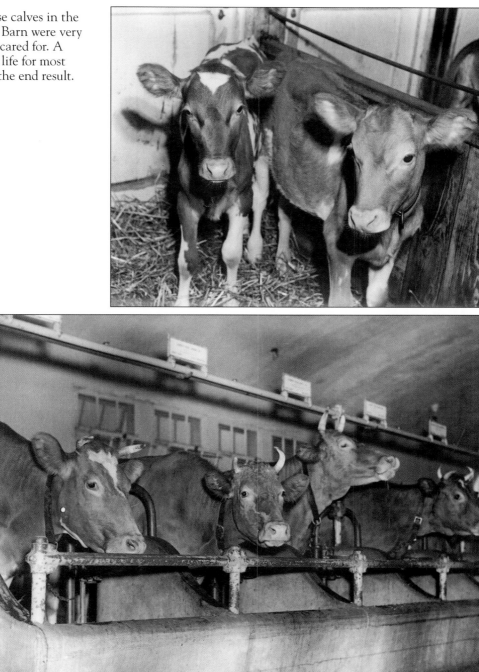

A common sight on the dairy farm was cows being milked in their stalls. After a day of eating grass or hay, the cows actually looked forward to being milked. As the cows returned to the milking barn, staff simply opened the doors, and each cow would proceed to her milking station, winding up in the same location every time.

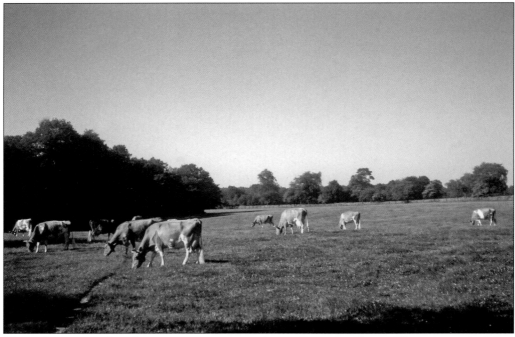

Shown here is another day in cow pasture paradise at Caumsett Farms. The cows were always fed grass over hay whenever possible. Cow pastures were rotated as feed sources, as dairy barn supervisor Ken Berry found that his cows most enjoyed the very tops of the grass.

Ken Berry checks one of Marshall Field's prized cows. It should be noted that most cattle have horns. This cow was a member of the award-winning Caumsett "Lilly" family.

Caumsett Ocean Burma, daughter of the infamous Caumsett Dynamo, is seen here with Ken Berry (right) and John Clark (left). All of Marshall Field's livestock were named, an uncommon practice in the industry. The woman at center is Mrs. Barclay, wife of the mayor of Lloyd Harbor at the time.

The name at the lower right reads "G.K. Dunning." He came over from England at Marshall Field's request. It was his job to provide oversight to the building of the estate and to ensure the duplication of a true and original English manor. He was also responsible for accumulating the livestock and, with a virtually unlimited budget, purchase for Marshall Field only the absolute best. Knowing that the product would be sold commercially, Field started an advertising campaign to build the Caumsett Farm brand. This advertisement from *Country Life* magazine may have served to line up future purchasers for offspring.

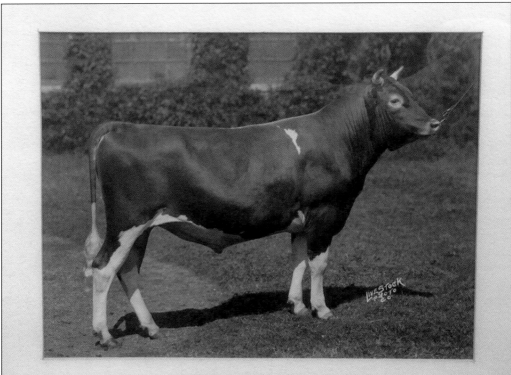

CAUMSETT HARVESTER 145445
SOLD AT AUCTION FOR $4500
JUNIOR CHAMPION AT WATERLOO, MINNESOTA AND IOWA, 1929
FIRST PRIZE JUNIOR YEARLING NATIONAL DAIRY SHOW, 1929

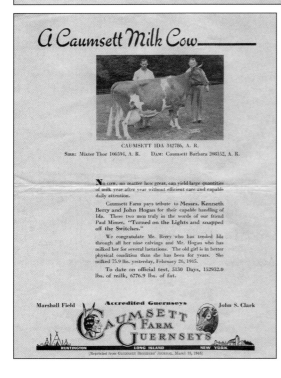

Caumsett Harvester won first prize in the junior division at the 1929 National Dairy Show. The bull was purchased soon thereafter by G.K. Dunning in late 1929 for $4,500. This indicates the quality that Dunning and Field were looking for—only the best of the best.

This is a pristine 1945 Caumsett Farm advertisement. This is another attempt at building the brand by showcasing an individual cow, this one named Ida, with exceptional lineage. All of Field's 100-plus Guernseys were accredited. While Ida's output may have been noteworthy, productivity was high on all counts in the milking barn. The advertisement states that Ida had recently milked almost 76 pounds—almost 10 gallons of product.

Caumsett Dynamo is pictured. The largest New York dairy in the 1930s was Borden's. Its advertising pitch came from a cow named Elsie and her "husband," Elmer. Elsie and Elmer were known the world over. There was no question as to who would represent Elmer at Borden's New York World's Fair exhibit in 1939—Caumsett Dynamo. Another Caumsett cow was selected to play Elsie. It was a proud moment for dairy barn supervisor Ken Berry.

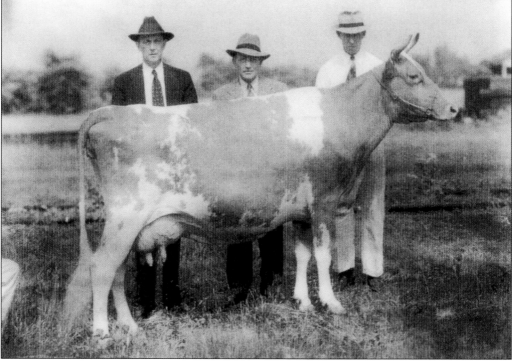

The purchase of a new cow was a big event at Caumsett. Shown here are Caumsett estate superintendent John S. Clark (left), the unidentified seller (center), and Ken Berry, the dairy barn supervisor.

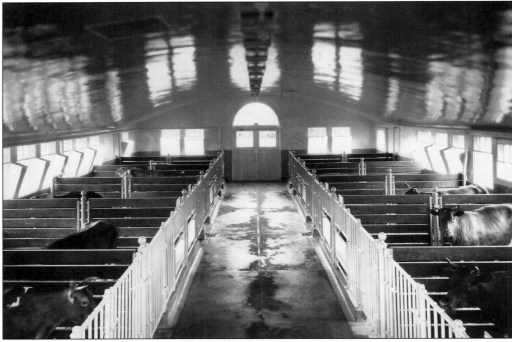

The Cow Barn is shown here in its natural state of operation. This area was not cleaned up for this formal photograph. It was always in this condition. Marshall Field demanded nothing less than exceptional care for all of the animals on his estate.

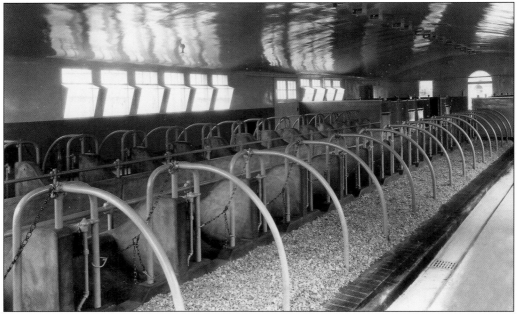

This is the milking area of the Cow Barn. Note the absence of automated milking machinery. In the mornings before school, after school, and sometimes again after dinner, the male teenagers on the estate had the job of milking the cows, among many other chores. These were not idle kids, and Marshall Field paid them well for their efforts. Most dairy cows at the time were milked twice a day. The superior cows at Caumsett were often able to be milked three times a day.

Floyd Dolliver, also known as "the Dairyman," was a one-man automated production machine. It was his job to get the collected milk sterilized, and then bottled, in the least amount of time possible. This was important, as Caumsett milk was not pasteurized. Dolliver also made butter, cream, and buttermilk. He even arranged for the sale and distribution of all leftover milk-based products. He is shown here working the bottling machine. On this day, quart bottles were being filled.

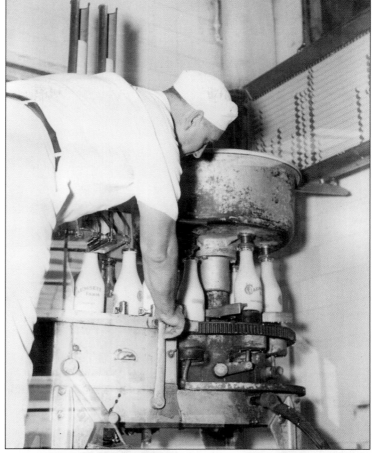

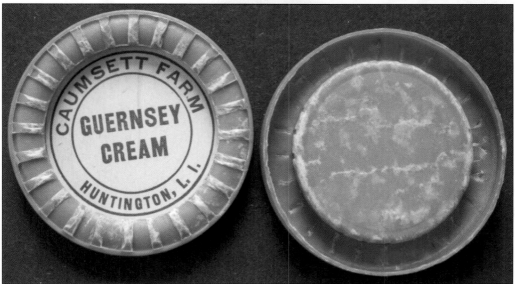

Shown here is a Caumsett Farm quart-sized bottle cap. Caps were attached by hand and formed in place with a manual cylinder-equipped pressing machine.

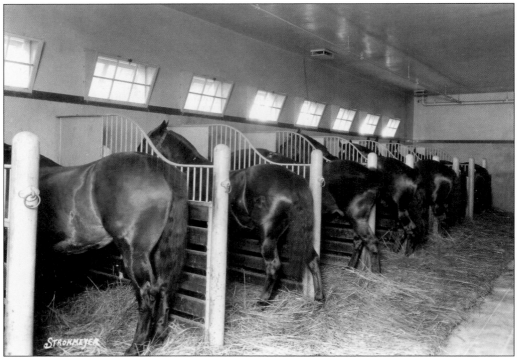

CAUMSETT DYNAMO
8 - 3 - 1936 — 7 - 18 - 1953
CAUMSETT IDA
7 - 1 - 1931 — 2 - 3 - 1949
CAUMSETT BELMA
11 - 7 - 1932 — 2 - 27 - 1953
CAUMSETT OCEAN LEDA
10 - 23 - 1941 — 8 - 2 - 1953
CAUMSETT COUNTRY VIOLET
3 - 25 - 1936 — 8 - 17 - 1954

State-of-the-art interior designs at Caumsett featured, for the first time in any commercial barn, a passive ventilation system that kept the air clean and a system for cleaning cow effluents that was built into the concrete floor. Cows at Caumsett lived long lives, probably due to the fact they were so well cared for and lived in a clean environment. Those who provided their care became very attached over the years. When a cow passed away, it was usually buried on-site. A granite tombstone marks the area behind the hay barn.

These beautiful horses are not to be confused with Marshall Field's prized polo ponies. This group of horses was housed in the Dairy Barn Complex. They were the mechanical backbone of the estate until mechanization arrived in tractor form in the early 1930s. They were responsible for plowing the fields, smoothing road surfaces, and moving material around the estate.

Caumsett employees on the estate dock are about to enjoy a boat outing. Boat trips to Glen Cove, Port Jefferson, Cold Spring Harbor, and Connecticut were popular forms of entertainment for the staff on a day off. Caumsett had no shortage of staff or applicants. In the 1930s, it was not difficult to find workers, because jobs were very hard to come by. Household staff, grooms, field-workers, and dairymen manned the estate, often doing the most menial tasks for hours on end. It must be remembered that this preceded the technology that evolved after World War II. Many hands were required to fire the coal furnaces, tend to the coal stoves, and make and deliver ice for the iceboxes. All in all, Caumsett was a very prestigious place to work. Marshall Field maintained a great relationship with his employees, respecting their efforts and paying them well.

These staff members, posing at the Engineer's Cottage, are probably dressed for an outing in Huntington. Caumsett employed more than 100 people in the late 1920s and up to the start of World War II. More than half lived on the estate, many with their families.

This was the estate manager's private beach house, located near Roosevelt's Cove. Leaving his car at what today is the site of the fisherman's parking lot, John S. Clark would walk down to this small house on the estate shore. This area of the beach, used by the Farm Group, was called Farm Beach. With almost four miles of unprotected shoreline, Caumsett received its share of uninvited visitors over the years. They often arrived by boat and would light bonfires on the beach. John Wesley Dickey was originally hired as a painter and carpenter from Huntington. He soon found a more exciting job on the estate. In 1933, he was made the night watchman. He was stationed at the office where the main switchboard was located. Dickey, who wore a uniform and carried a gun, was the first and only estate policeman.

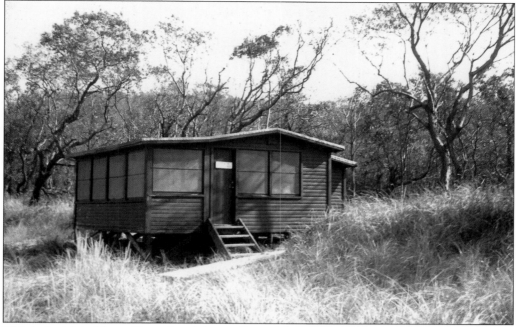

This is the Main House Group beach house. East of the Main House, a separate section of beach was used by the staff of the Main House Group and was known as Main House Beach. It was situated where the parking lot for the Fiddlers Green Association beach is currently located.

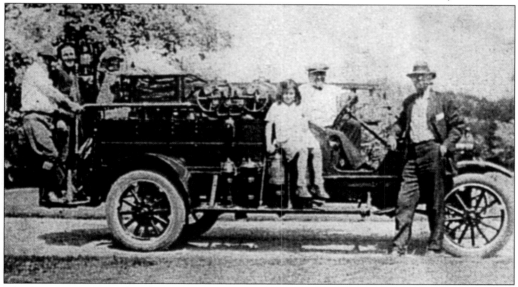

The Dairy Barn Complex also contained an interesting piece of equipment, a real fire engine. In early 1939, the top floor at the Risebrow cottage caught fire. A well-rehearsed group of employees manned an orderly line of water and sand buckets that were passed back and forth, extinguishing the fire just as the first truck from the Huntington Fire Department was arriving. Field knew that all family member structures on the estate were built to be fireproof, but the same could not be said of any staff building on the property. Immediately after the fire, he instructed John Clark to procure a fire truck and any necessary equipment for it. Clark purchased the used 1925 American LaFrance model shown here for $300.

Grooms Dick (left) and Billy pose at the Polo Barn's entrance road, which no longer exists. Estate manager Clark had a tennis court built for the employees where the present-day parking lot is located, at the top of the service drive. In the winter, the court would be surrounded by wood, flooded, and used for staff ice-skating and hockey. Alfie Kuntz remembers that a tent was set up next to the "rink," and refreshments and skating equipment were provided for staff use. Skating took place at the fresh pond behind the Main House, as well.

Albert Edward Risebrow, was born in 1891 in North Repps, England. He came to America in 1913, and was employed by several different families in New York City as their driver. He served in the US Army during World War I, and married Theresa Sullivan in 1915. Risebrow came to be known for his superior service and automobile knowledge. In 1924, he met Marshall Field III and was immediately offered the job of head chauffeur. Two children, Dorothy and Albert Jr., would complete the family. Albert and Theresa are shown here with their personal vehicle in front of their cottage at Caumsett.

Lisa Risebrow remembers her grandfather: "He was Marshall Field's head chauffeur, and in the heyday, had many drivers under him. He spent a lot of time in NYC, as Mr. Field had a passion for helping the children of refugees, and they would drive to the docks to greet them. One of my fondest memories was of him letting us ride around in the Red Bugs when the Fields were not in residence. How we loved those Red Bugs! My grandfather was also in charge of automobile maintenance at Caumsett. That meant that he could put a vehicle on a lift. Young boys, especially, enjoyed the wonder of exploring the automobiles from underneath. It was a 'hands-on' education on the workings of the internal combustion engine. Of course, the price of being allowed to participate in this fun was being a part of the cleanup crew. 'Dede,' as we called him, was known for not tolerating so much as a spot of oil on his immaculate garage floor. My grandfather was a wonderful, kind, and sophisticated man in every way." Lisa's father is shown on page 80.

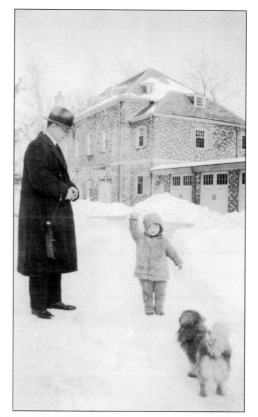

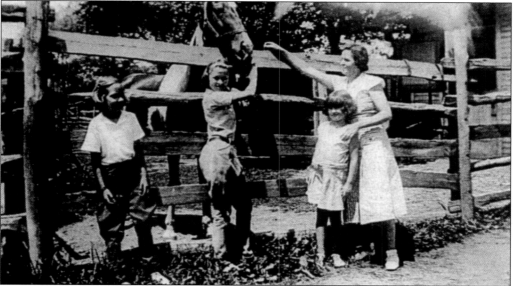

Bettine Field is shown on the left in the stable area with her governess Nelle (right). The other two children are members of staff families. The Field children were very good friends with numerous staff members' children. Nelle was always referred to as "Mademoiselle," as was the custom at the time. She was never called by her first name. The children's governesses were very well paid, but the job was demanding, as they were never far from the children. (Courtesy Gwen Fayers.)

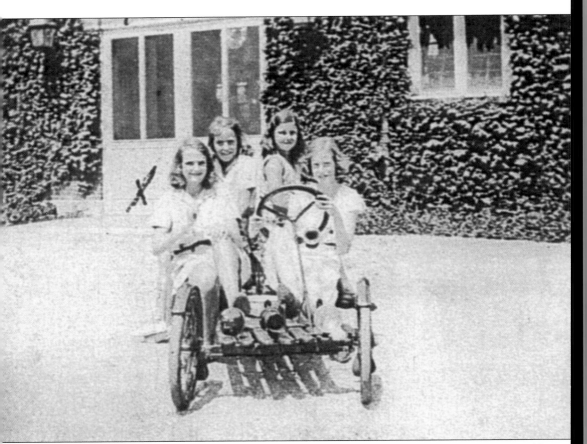

The Cushings were a wealthy Chicago family who often spent time at the estate when the Fields were present. They stayed in the Summer Cottage. "Bunny" Cushing (left) is seen with Polo Barn staff children, including Gwen Fayers (second from right). For this 1932 photograph, the children are seated on a Red Bug electric vehicle in the Polo Barn courtyard. Note how kids from two vastly different social classes were allowed to play together. This was not often the case on other estates. Alfie Kuntz commented on this remarkable fact during an interview: "We were initially afraid to go near the Field family children and their numerous guests. However, due to their limited time on the estate (they would often travel between several homes), we knew much more about the 'cool' places to play than they ever would. The employees and servants children always had such a great time playing together, that it seemed just natural for the 'rich kids' to want to join us. Much to the surprise of many of our parents, they were, allowed to do just that!" (Courtesy Gwen Fayers.)

Pictured here is a donkey born at Caumsett. The donkey's parents were a gift to Marshall Field from the people of Ethiopia as thanks for a donation to the country's health system. Field's generosity extended all over the world. There is perhaps little doubt that he would have signed today's Giving Pledge, in which the super-wealthy pledge to donate at least half of their fortune to charity upon their demise. (Courtesy Gwen Fayers.)

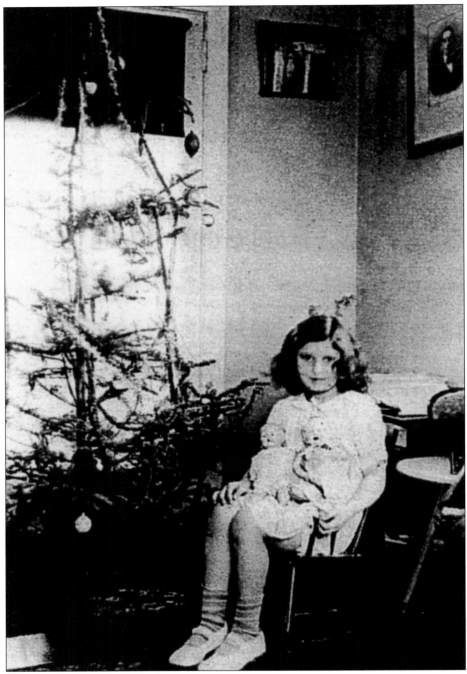

Gwen Fayers was interviewed at 82 years of age about life at Caumsett: "I clearly remember Christmas at Caumsett. The beautiful white snow on the never-ending landscapes. Mom, Dad, and I would load presents in the car and travel all around the estate giving them out. When we got home, we would unload the same amount! It was so wonderful. I was so sorry to leave." Gwen's mother came down with pneumonia in 1933 and almost died. The Field family paid for all of her medical care and hired nurses to stay with her 24 hours a day. Fayers did recover, and the family returned home to England a few months later.

Eight

THE DEATH OF
MARSHALL FIELD III

On October 21, 1956, Marshall Field III took ill while staying at his beloved Caumsett. He was rushed to Huntington Hospital and then transferred to New York Hospital, where he was diagnosed with a blood clot in his brain. He underwent a noneventful surgical operation the next day. His post-op condition was reported as "fair," and he remained in the hospital for observation. On November 7, his condition began to worsen, and his wife, Ruth, was called to his bedside. She was present when he passed away at 5:00 a.m. on Thursday, November 8, 1956, at the age of 63. Ruth Field requested that, in lieu of flowers, donations be made to Field's favorite charity, the Children's Welfare League. From all over the world, tributes poured in to Ruth and her family. Perhaps the *New York Times* spoke for most when it wrote, "Field was a millionaire like none other, who devoted himself to liberal causes and a philanthropist who aided race relations."

Marshall Field's will took care of Ruth and most family members, but he left the bulk of his estate to the Field Foundation to continue with his numerous charity interests. In his will were specific instructions for monetary distributions to his Caumsett staff. Each employee received a payment based on his or her job function and years worked. The employees were overwhelmed, but not surprised. They knew their employer well, and it is not a stretch to say that he was loved and respected by one and all.

By January 1957, the lawyers did what lawyers do, and life went on at Caumsett. Ruth Field was given title to all residential properties, including Caumsett. She chose to continue the family move from the Main House to the Summer Cottage. Once there, she proceeded to upgrade the landscaping and interior decorations, using material and furniture from the Main House. In January 1957, she received her first monthly expense payment for the operations at Caumsett. It was for $21,000.

THE WHITE HOUSE
WASHINGTON

November 9, 1956.

Dear Mr. Field:

I want to express to you my deep sympathy
in the loss of your father. Despite the per-
sonal sorrow you must feel at this time, I am
sure you also take comfort and satisfaction from
all that your father was able to do -- through
his contributions and interest -- to improve
the health, education and living standards of
the people of our country.

With warm regard,

Sincerely,

Dwight D. Eisenhower

Mr. Marshall Field, Jr.,
Chicago Sun-Times,
211 West Wacker Drive,
Chicago 6, Illinois.

Shown here is a letter to Marshall Field IV (Junior) from Pres. Dwight D. Eisenhower, reflecting on the loss of his father.

In 1925, John Spencer Clark was hired as a Dairy Barn Complex manager. He soon found himself promoted to estate manager, in charge of every detail at Caumsett. He knew the history of every cow. He knew what horse was running in what race at Belmont, and how it would be transported there. He knew when the Fields wanted to travel before they did. In short, Clark was the grease in the wheelhouse, the one who put it all together and made it all work. He stayed on until the very last day; he got in his company car and took one final tour.

John Spencer Clark is shown in the abandoned indoor tennis court.

John Clark walks the Master's Beach House tennis courts for the last time. Like the salt water from the pool, the atmosphere had by now been drained from the Gold Coast estate of Marshall Field III.

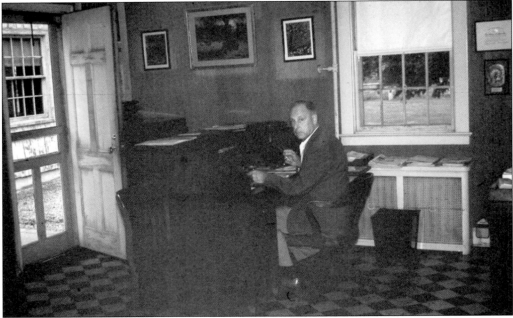

John Spencer Clark is shown at his secretary's desk on February 1, 1961. It would be his last official day at work for a member of the Field family. A guy named Moses would be taking over the very next day. For 38 years, morning mail had been sorted on this desk.

This photograph taken by retired head gardener George Gillies in the early 1970s shows friends at his Caumsett home (pictured on page 48, bottom). Note the photograph of Marshall Field on the table behind them. For the most part, Field's employees were fiercely loyal to him and remained grateful for the way in which their employer treated them when interviewed years later. The Gillies were granted "life rights" to the home, courtesy of Ruth Field.

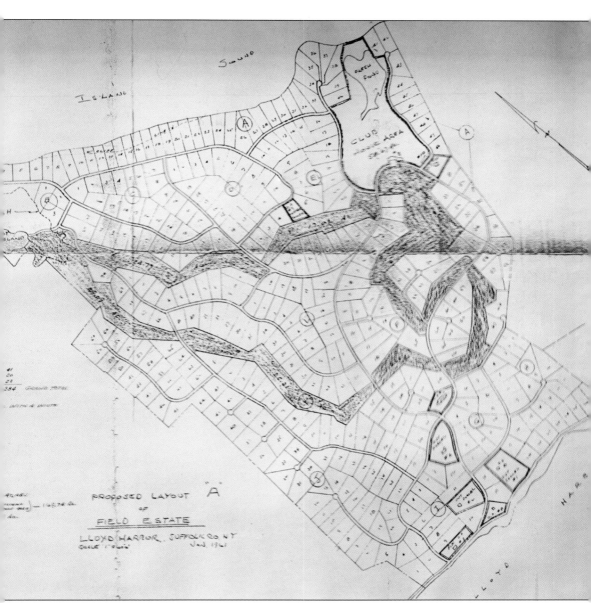

This is perhaps the most amazing item in this book. It is a plan of what the Marshall Field III estate would have become if not for one person and her willingness to carry out the wishes of her husband. In 1956, Ruth Field inherited $1 million in cash and all of the Field family real estate holdings, including Caumsett. Within a period of eight months, more than 100 offers to purchase the Caumsett property were delivered to Field. The most serious came from a developer, who enclosed the plan shown here. He was willing to pay top dollar for the purchase rights. But his money would not be enough. Forty years after the ground-breaking ceremony at Caumsett, Field opened bids for the right to purchase the estate and all that it had become. The winning bid, in excess of $5 million was from the developer. A second bid came from Robert Moses, then parks commissioner of New York State. It was for more than $1 million less. Field took a moment to reflect on her life and what her now deceased husband would have wanted. She turned to trusted adviser and confidant Adlai Stevenson and stated that she wanted to accept the lower bid. Fourteen months later, Caumsett State Park was born. (Courtesy Gwen Fayers.)

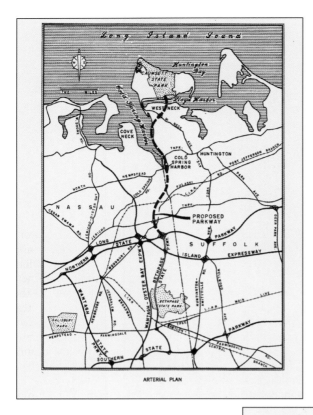

ARTERIAL PLAN

Around the New York State Parks office, a certain park in Lloyd Neck was referred to by a code name: "Junior Jones"—"Junior," as in small; "Jones," as in Jones Beach. Moses was going to make Caumsett a scaled-down Jones Beach. To begin with, Moses needed an efficient and modern way to get people to his new park. The Meadowbrook and Wantagh Parkways in Nassau County seemed to be getting people to Jones Beach just fine. It was decided to build on that success with a parkway—a four-lane highway—from the existing Bethpage State Parkway to Caumsett. It would be named the Caumsett State Parkway.

PLAN OF

CAUMSETT STATE PARK

AND PRELIMINARY STUDY OF

APPROACH PARKWAY

LONG ISLAND STATE PARK COMMISSION

MAY 22, 1961

On May 22, 1961, Robert Moses announced his plans for the Caumsett State Parkway. This plan showed for the first time the enormous impact the highway would have on the villages of Cold Spring Harbor and Lloyd Harbor.

108

Nine

THE FOUNDING AND DEVELOPMENT OF CAUMSETT STATE PARK

On February 2, 1961, Robert Moses, then New York State parks commissioner, gave a speech in front of the press on the steps of the Caumsett Main House: "The Long Island State Park Commission offers its sincere thanks to Ruth Field and Ambassador Stevenson, President of the Field Foundation, for their generous cooperation in making possible the acquisition of Caumsett, one of the finest remaining privately owned estates on Long Island. The purchase price of $4,278,000 paid for the property represents a substantial donation by Mrs. Field, made because of public benefit and interest in conservation. The estates 1,426 acres will be known as Caumsett State Park. The park has over two miles of frontage on the Sound, and many buildings usable for park purposes. Plans are being made for the development of the park for conservation, wildlife refuge, an arboretum, nature trails, golfing, picnicking, bathing and boating. On behalf of my colleagues, I am delighted to accept the conveyance of this new park for the people of the State of New York."

No mention of funding of any kind was made. While state expectations ran high for "Junior Jones," reality would intrude on Moses's grand plans. It would be more than 10 years before Caumsett would receive its first significant budget consideration: $30,000 for employee salaries and an additional $10,000 for maintenance and repair. For 1974, the park manager requested $75,000 for the process of simply "holding" the park in its decaying state. He would receive the same allocation as in 1973.

Newspaper headlines however, were crystal clear: "Unspoiled Beauty Is Challenge To Decision Makers," "Lloyd Neck Bridge To Stamford," "Villagers Fight To Retain Pastoral Setting," "Marshall Field Park Acquisition Called High-Handed." The so-called power broker, Moses, was accustomed to getting his way. He now owned 24 percent of the land in the village of Lloyd Harbor, and suddenly he found people getting in the way. It was Moses against Lloyd Harbor, and Moses was winning. The village government saw the writing on the wall and tried to deal with him. When presented with four concepts for an access road to Caumsett, it selected the plan that would do the least amount of harm to the village and its people. In 1964, the village sold 27 acres of parkland to the state for $95,000. Things were going well for Moses. He would get his Caumsett State Parkway, and then possibly go straight across Lloyd Neck with a bridge to Stamford, Connecticut.

On October 10, 1967, residents' mailboxes had a letter from the first woman trustee to serve the village. Elizabeth Long Burr had had enough of Moses and his grand and expensive plans (estimated at $24 million in 1961 terms) for Caumsett and her village. She organized the Caumsett Citizens Committee and set a seemingly simple goal: "To have Caumsett State Park preserved in its entirety for nature education and nature-oriented recreation." Her letter that day concludes with: "Please note that any effect that this may have on roads, bridges, nuclear plants, jet-ports-in-the-Sound, and other such horrors is incidental to the main effort of this Committee."

Moses vs. Burr would play out in the newspapers, courts, and in local and state public meetings. In the end, Moses would take a loss for only the second time in his storied career, and Burr's committee would declare victory not for itself, but for the people of the village of Lloyd Harbor and of New York State.

The Caumsett estate became a land of rules and regulations. State employees were brought in to figure out what to do with the remaining facilities and the acres and acres of well-preserved land. Marshall Field's facilities manager, Albert E. Kuntz, became a New York State employee after spending 40 years with Field. He was given the honor of being Caumsett's first park manager, a seemingly natural choice, as he knew everything there was to know about the former estate.

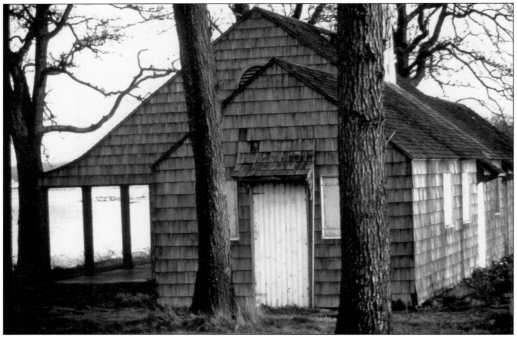

Kuntz got to know his new job and his new bosses. He quickly came to two conclusions: first, no money to maintain the park and its assets would be coming anytime soon; and, second, there was no way for him to do anything about it. He decided to mothball Caumsett for its own protection. It should be noted that, while the park was acquired in 1961, it did not open to the public until Saturday, July 17, 1976—some 15 years later.

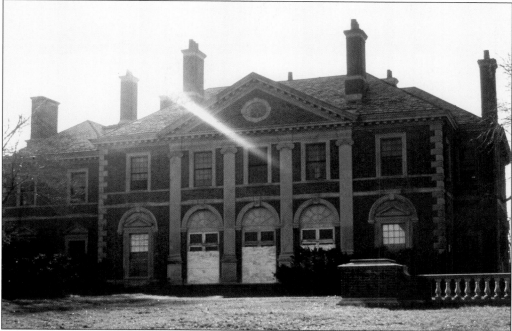

Seen here is the boarded-up Main House. Alfie Kuntz remembers: "My dad was the park manager at the time and felt he had no choice but to try and place the buildings in a state of suspension. There was no money available from the state for renovations let alone simple maintenance. I remember being in the Main House draining water from the pipes. It was cold, damp and empty. Completely empty. It was heartbreaking." Vandalism was now taking place all over the estate. Former superintendent John Clark's stately home (shown on page 46) was stripped of its contents and burned to the ground.

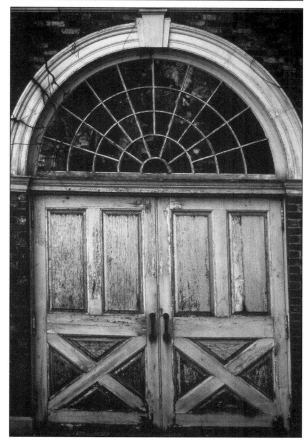

These are the once stately doors of the Polo Barn.

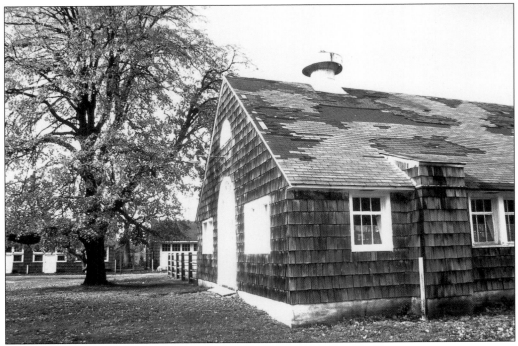

The once proud Dairy Barn Complex shows signs of wear.

Supports hold up the garage area of the Dairy Barn Complex.

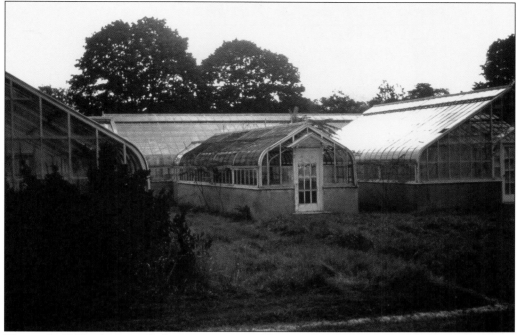

This early-1960s photograph shows the abandoned greenhouse area. The complex was subject to extreme vandalism and was damaged almost to the point of no return. The state decided to tear it down due to perceived safety problems (broken glass and twisted metal shards), but a local Lloyd Harbor resident fought back and worked to have it declared a historic landmark.

A gate allowing access to the greenhouse complex carries a warning to employees.

This March 1965 drawing of Robert Moses's "Master Plan" for the Caumsett State Parkway shows the connections that would have been added. Duplicating the South Shore connectivity, the Bethpage State Parkway would have become the Caumsett State Parkway after the Northern State Parkway junction. Plans were made to go west to Bayville across Cold Spring Harbor, and east to Eatons Neck, across Huntington Harbor. The Long Island Park System would have been completely connected.

Making a right turn at the Lloyd Harbor Village park, and going up the hill, the Caumsett Parkway would have passed on the south side of the Seminary complex, before making a slow left over a bridge at Lloyd Harbor and then going straight into the park. The parkway would end in a traffic circle between the Dairy Barn Complex and the Polo Barn.

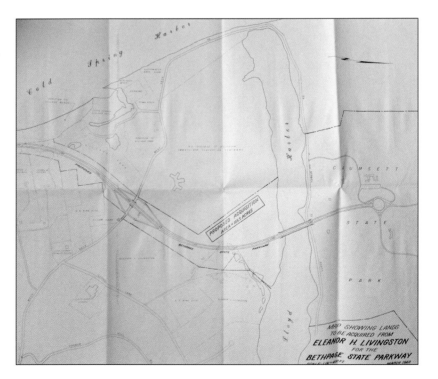

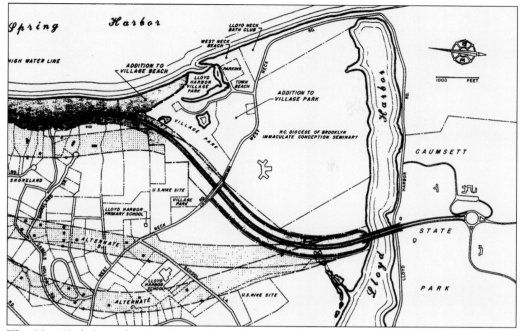

This New York State drawing shows the parkway's preferred route. However, just in case Robert Moses did not get his way, two alternative routes are displayed. They would have decimated Lloyd Harbor. It is hard to imagine, for instance, a four-lane parkway next door to the Lloyd Harbor School.

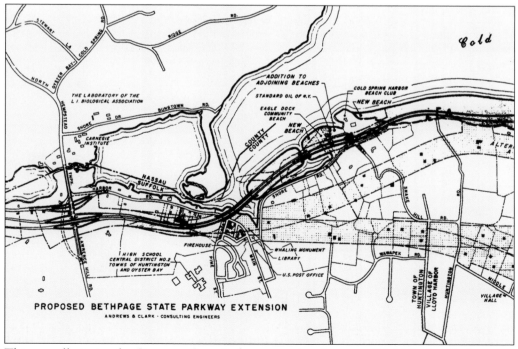

This map illustrates the Caumsett State Parkway entering the area of Cold Spring Harbor.

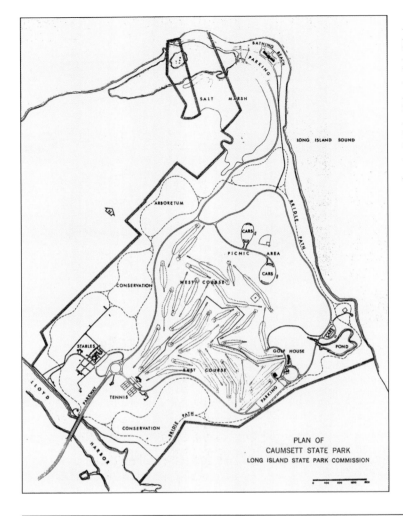

As for plans for the park itself, Robert Moses knew exactly what he wanted to do. He gave the park the code name "Junior Jones," as he wanted a North Shore version of his crowning achievement, Jones Beach.

This is a cross-section of the Caumsett State Parkway near the current Eagle Dock Association property.

Realizing that he was losing his battle for "Junior Jones," Robert Moses submitted a scaled-back plan for Caumsett State Park.

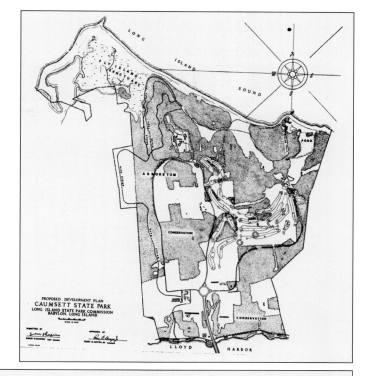

PROPOSED DEVELOPMENT PLAN
CAUMSETT STATE PARK
LONG ISLAND STATE PARK COMMISSION
BABYLON, LONG ISLAND

A four-lane highway going to Caumsett, with a large junction at the Northern State Parkway, was planned. The estimated cost for this parkway alone was $24 million. All of this would shuttle an estimated 2,000 vehicles a day in and out of Caumsett. To many people, this seemed excessive.

Plan For Bridge

(Continued from page 1)

4-YEAR-OLD PLAN FOR LLOYD NECK BRIDGE TO STAMFORD DISCOVERED

© L.I. Commercial Review, Inc. 1965

Verification of claims that "60,000-car daily capacity of the Bethpage Pkwy Extension for which 500-ft-wide rights of way are now being acquired through Cold Spring and Lloyd Harbors is much too big just to provide access to the promised 'limited use conservation and wild life refuge' Caumsett State Park" came yesterday with discovery of a hitherto unrevealed "Proposed Bridge Crossing from Lloyd Neck, L.I., to Stamford, Conn." study.

A storm of opposition has been raging in both the Oyster Bay and Rye areas over the L.I. Sound Crossing Bridge proposed in Feb. by Robert Moses between those 2 points. On Oct. 6, Robert Moses and the L.I. State Park Commission which he formerly headed was accused of "secretly planning a network of 4-lane super hwys and bridges along the north shore tieing the dead-ended pkwys together in a L.I. Sound Pkwy".

The accuser is Malcolm Tillim, asst town atty of Huntington and Democrat-Liberal candidate for the Assembly (6th District). He has been supported in his charge of "secret planned pkwys and bridges network" by the Cold Spring-Lloyd Harbors Preservation Committee of "mostly Republicans" and by the L.I. COMMERCIAL REVIEW, regional daily business newspaper.

"This secret Lloyd Neck Bridge proposal makes it apparent that Robert Moses and the L.I. State Park Commission have long considered Lloyd Neck as a prime prospective terminus for a sound crossing," said Warren Kraft (Cold Spring Harbor) and Mrs. B. Tappen Fairchild (Lloyd Harbor), co-chmn of the Cold Spring-Lloyd Harbors Preservation Committee. "Obviously, the Park Commission is pushing ahead rapidly to ac-

PROPOSED BRIDGE

LLOYDS NECK, L.I. to STAMFORD

**LOCKWOOD, KESSLER & BARTLETT,
CONSULTING ENGINEERS
SYOSSET, N.Y. FEB. 1961**

for a "complete cessation of acquiring property for the Bethpage State Park Extension to Caumsett Park until such time as the nec-

Pkwy (now terminating at Veterans Memorial Hwy) with the recently-acquired State Wyandanch preserve (Smithtown) and then

bridge to Conn. and the bridges and pkwys of a future L.I. Sound Pkwy linking together Bayville, Lloyd Neck, Eaton's Neck, Asharoken, and Sunken Meadow."

Tillim pledged, if elected next week, to fight construction of the Caumsett Pkwy and the Lloyd Neck to Stamford Bridge and to introduce legislation in Albany to curb the power of state agencies in planning new roads and recreational areas.

The L.I. COMMERICAL REVIEW for 4 years has been editorially asking for justification of the Caumsett "sunny summer Sunday parkway to nowhere" announced on May 22, 1961, by Robert Moses, then head of the L.I. State Park Commission. On Mar. 18 this year, it printed a map of "existing, projected, and not-yet-revealed but planned state parks and pkwys in Nassau and west Suffolk. It showed a L.I. Sound Pkwy linking the now dead-ended Sunken Meadow State Pkwy to Caumsett Park by way of Asharoken, Eaton's Neck and a bridge to Lloyd Neck. By another bridge it jumped to Centre Island and then to the Bayville terminus of the proposed Oyster Bay to Rye Bridge and projected Wantagh-Oyster Bay Expwy.

The REVIEW has many times quoted Moses' prediction that "private clubs can no longer be maintained within 40 miles of N.Y. City" and it has pointed out that all his parks and pkwys link together on the south shore, that the link between the present dead-end of Northern and Southern State Pkwys is currently being surveyed, and that therefore it is "only a matter of time" before the Sunken Meadow Pkwy and the under-acquisition Bethpage-Caumsett Pkwy will also be linked.

The REVIEW has also pointed out that Moses uses waterfront for pkwys wherever possible (he calls them "ribbons of parks for leisurely driving"). For example: East River Drive, Brooklyn's Shore Pkwy, Little Neck's Belt Pkwy, and Jones Beach Ocean Pkwy. And for 30 years, he tried to put a pkwy on Fire Island linking the Robert Moses Bridge to the Smith Point Bridge, a project now permanently blocked by the Fire Island Nat'l Seashore.

The pkwy opponents argue that past performance, logic, and now this hitherto hidden 4-year-old engineering proposal support a "secretly planned north shore bridge & pkwy network". They say that Moses has often openly criticized planners for letting the public know their plans in advance of action. For example, in 1960 Moses blasted as "simply premature" the Regional Plan

A local business paper announces the discovery of a plan to build a cross-sound bridge from Caumsett to Stamford, Connecticut. Was Robert Moses planning something bigger in Lloyd Neck? Public plans released in 1954 state that his choice route for the bridge was from Oyster Bay to Stamford. Upon purchasing Caumsett, and building his planned four-lane, $24 million (1961 estimated cost) road from the Northern State Parkway to Lloyd Neck, would it have not made sense to simply continue to Connecticut? It certainly appears that the answer would have been yes.

118

Ten

A NEW BEGINNING

In 1994, George Pataki was elected governor of New York State. He appointed Bernadette Castro to be the new commissioner of the New York Office of Parks, Recreation and Historic Preservation. Castro would hold the office for 12 years, making great strides in the improvement of the New York State Parks system. In 2003, she achieved nationwide recognition when the National Recreation and Park Association awarded New York State its highest honor, the National Gold Medal.

Lloyd Harbor resident Carol P. Swiggett had always placed a high value on the special community that she and the Field estate were a part of. She served as the trustee of the Village of Lloyd Harbor, with the responsibility for oversight of the Village Conservation Board. At a board-sponsored symposium in 1995, Commissioner Castro spoke of making New York State parks more self-supporting and endorsed the concept of private-public partnerships.

A member of the conservation board stood up and asked Castro if she would entertain the idea of a "friends" group for Caumsett. When she replied that she certainly would, he immediately nominated Swiggett to be the first president, with the rest of the conservation board as members. A very surprised Swiggett graciously accepted the challenge, and the Caumsett Foundation was born. Its first order of business was to start raising money. At about the same time, funding for state parks had been increased, thanks to the success of several state bond programs. Money for desperately needed repairs started to flow to Caumsett.

Carol Swiggett remembers those early years:

> In early 1996, J. Winthrop Aldrich, deputy commissioner for historic parks, sent me reams of historical background on Marshall Field III and a chart of descent to show where we should look for documentation on Caumsett and possible funding support. The Marshall Fields V and VI showed immediate interest and were very responsive and supportive to our requests. Later that year, Commissioner Castro sent an official from Albany with boxes of information relating to the estate. He seemed quite horrified when he arrived at our house, not an office, and found me with our 10-month-old granddaughter, who was intent on going through his briefcase. By the end of the meeting, she was sitting on his lap and both looked quite happy. Our need to raise funds was very apparent, but no organization would share their membership list with us. It took three days with the help of Margie Howe and Hope Reese to put together a mailing list. We had no idea if anyone would come to our first benefit, but thankfully, it turned out to be a huge success. It was obvious that the community loved Caumsett. I could not have started the Caumsett Foundation without the dedicated group of volunteers whose drive and spirit were a constant source of inspiration. I am so proud of what we have accomplished.

Park manager G. Duke Rosenbauer proudly stands next to a new Caumsett welcome sign. The occasion was the former estate's elevation in the New York State Parks system to "historic" status. This status level afforded the park various means of protection from low-level development. The stated objective was to keep Caumsett as close as possible to a "passive use" facility in order to protect its treasured natural environment.

Parks commissioner Bernadette Castro (center) helps volunteers plant a tree, marking the occasion of the Caumsett State Park's official designation as a national historic site.

The state begins a cleanup of Caumsett. Bridle paths that had been blocked for years by downed trees were cleared. Roads were repaired, and dilapidated buildings beyond repair were removed.

Caumsett Foundation president Carol P. Swiggett paints the landscape behind the Main House overlooking Long Island Sound. She would later donate her work to be sold at the first foundation benefit.

The Main House living room is pictured here in 1997. The first Caumsett Foundation benefit featured an auction of works from local artists. All funds raised went to improving the park.

Foundation members Margret Hamilton Howe (left), Hope Reese (center), and Carol P. Swiggett arrange decorations for the 1997 benefit.

The foundation's first project was the complete restoration in 1998 of the Main House entry doors and mounting hardware. Working with parks department employees, and using photographs taken during construction in 1926, the foundation's contractor was able to restore the doors to original condition. During this "small" job, much was learned about the procedures necessary to ensure a proper historic renovation. The knowledge would soon be put to good use in other projects at Caumsett.

The second project the Caumsett Foundation funded was the planning and construction of a new park welcome center.

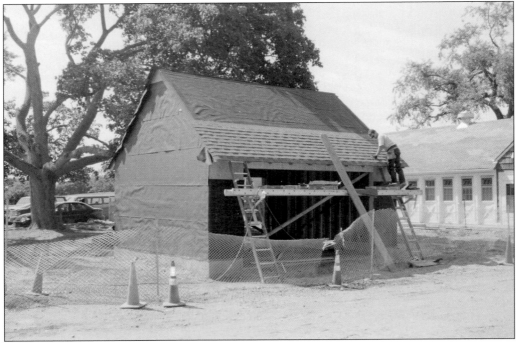

This photograph shows the park welcome center nearing completion.

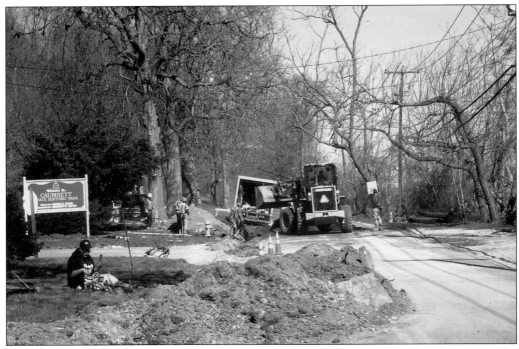

The state was also busy with major infrastructure improvements. Here, crews work on connecting the park to the public water system. Caumsett had relied on water wells since its inception in 1922.

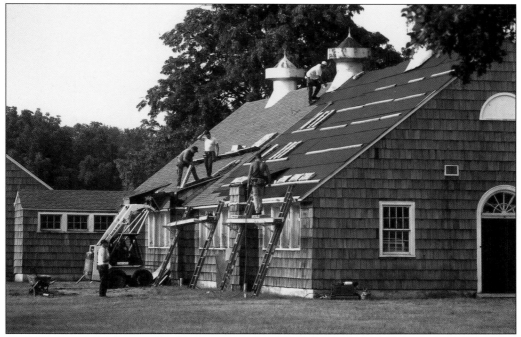

The Caumsett Foundation's third project was on a slightly larger scale—an immediate restoration of the Dairy Barn Complex. Funds were raised, and grants were received from private and state sources. The money was then spent on the exterior of buildings in the area. Interior renovations would have to wait for additional funding.

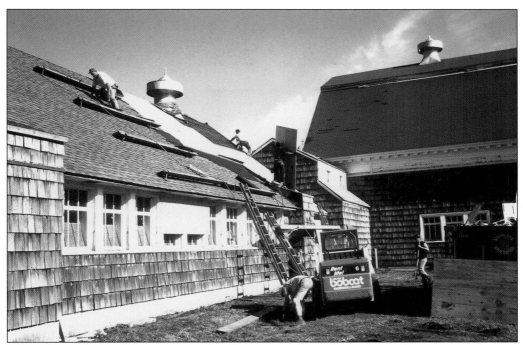

The milking barn receives much-needed care. The Caumsett Foundation worked with New York State historic preservation consultants to ensure the renovations were done correctly.

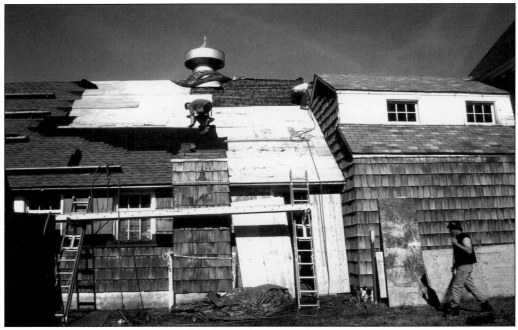

The Hay Barn receives a new roof and shingles. Extreme care was taken to match restoration components with the originals.

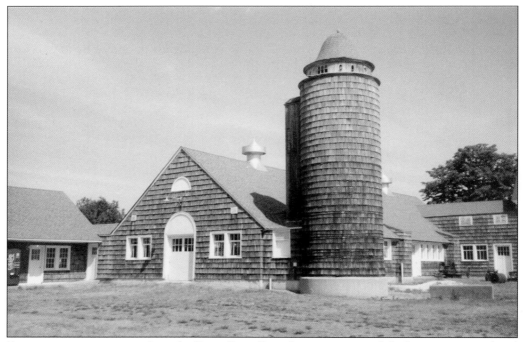

Exterior renovations complete, the Dairy Barn Complex appears as it did when it was completed in 1925.

ABOUT THE FOUNDATION

Early in 1996, the six members of the Lloyd Harbor Conservation Board met at the house of chairman Carol Swiggett to figure out what the new Caumsett friends group should do. They decided that the main objective was to maintain Caumsett's remaining 1,500 acres as a passive park. Traditional uses, like horseback riding, fishing, walking, bicycling, bird-watching, and environmental studies, were envisioned. They developed a mission statement, named themselves the Caumsett Foundation, and adopted the original Caumsett Farms logo: the Indian head inside the letter C. Since the friends group did not have a cent to its name, each board member chipped in $25. With this money, official stationery was printed, a park brochure was developed, the foundation was incorporated, and regular contact with New York State Parks commissioner Bernadette Castro was established.

As of March 2016, the foundation still has no paid staff. It is operated by a board of trustees consisting of community residents who are dedicated to the organization's mission: "to provide educational programs, low-impact recreation, historic and environmental preservation and conservation of the scenic value, natural heritage and cultural history of the former Marshall Field III estate." The foundation relies on memberships, grants, and program revenues to support its work. It is recognized by the State of New York as an "outstanding" model of a friends group supporting the efforts of the New York State Parks system.

The foundation's projects, done in conjunction with New York State Parks, have been wide-ranging and extensive in detail. The projects have transformed the Walled Garden from four overgrown acres of weeds and brambles to a place of serene beauty for quiet contemplation or for a spirited theatrical performance. They have meticulously restored the historic Dairy Barn Complex (which was almost beyond repair) and the exterior of the Polo Barn, the park's most architecturally significant building. Work is currently in progress toward restoration of the grasslands, once the home to many birds, butterflies, pollinators, and other wildlife beneficial to ecological health. The foundation sponsors hands-on educational programs and a cultural arts series in the spring and summer months.

While much has been accomplished, there is so much more to do. The Caumsett Foundation thus pledges to continue its work to enhance this magnificent preserve, not only for current visitors, but for the generations to come. We would certainly welcome your support. To find out more about the Caumsett Foundation or to help fund one of our many projects with a tax-deductible donation, please visit our website: www.CaumsettFoundation.org.

All author royalties paid from the sale of this book will be donated to the Caumsett Foundation.

—John F. Barone
March 2016

Discover Thousands of Local History Books Featuring Millions of Vintage Images

Arcadia Publishing, the leading local history publisher in the United States, is committed to making history accessible and meaningful through publishing books that celebrate and preserve the heritage of America's people and places.

Find more books like this at
www.arcadiapublishing.com

Search for your hometown history, your old stomping grounds, and even your favorite sports team.

Consistent with our mission to preserve history on a local level, this book was printed in South Carolina on American-made paper and manufactured entirely in the United States. Products carrying the accredited Forest Stewardship Council (FSC) label are printed on 100 percent FSC-certified paper.